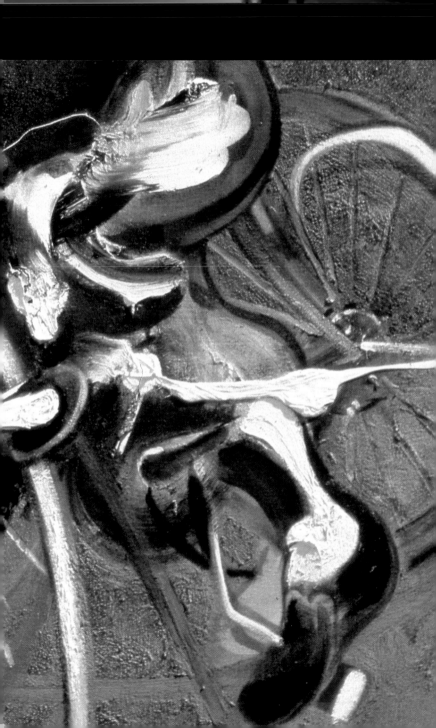

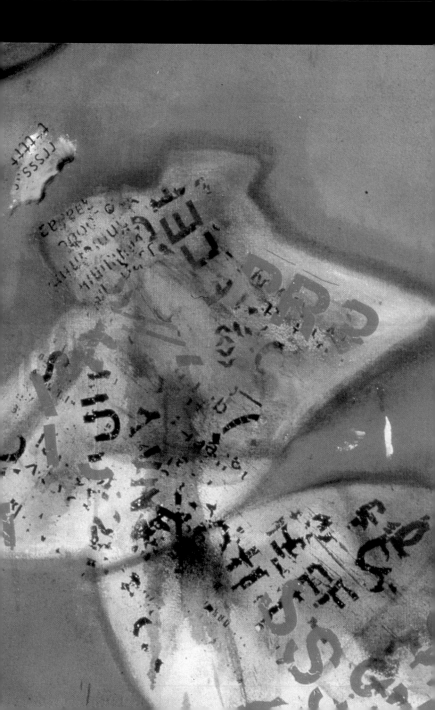

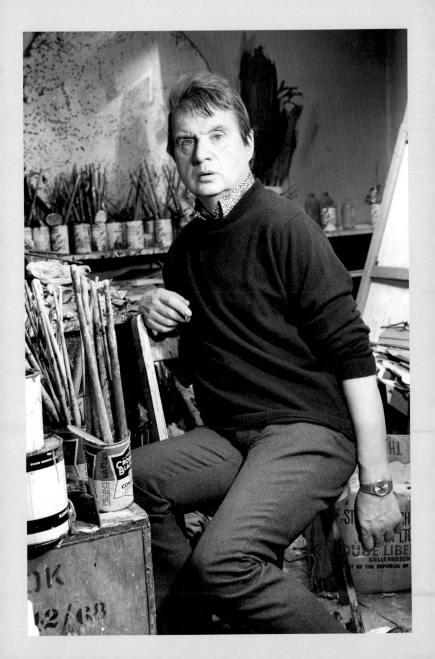

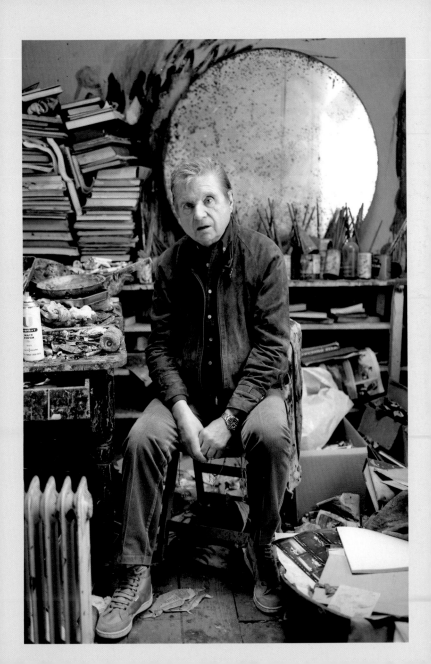

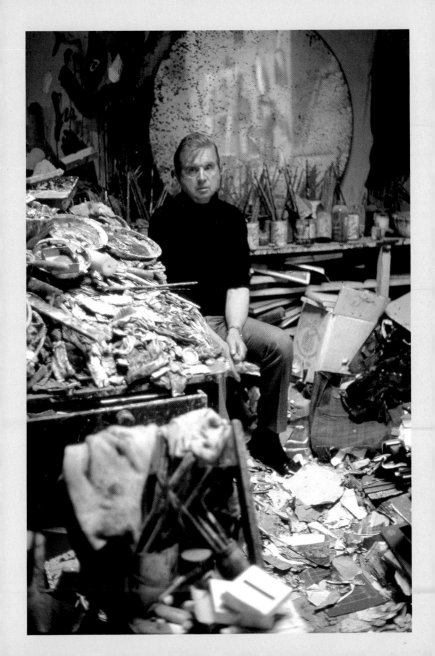

CONTENTS

FRANCIS BACON
PAINTER OF A DARK VISION

Christophe Domino

DISCOVERIES®
HARRY N. ABRAMS, INC., PUBLISHERS

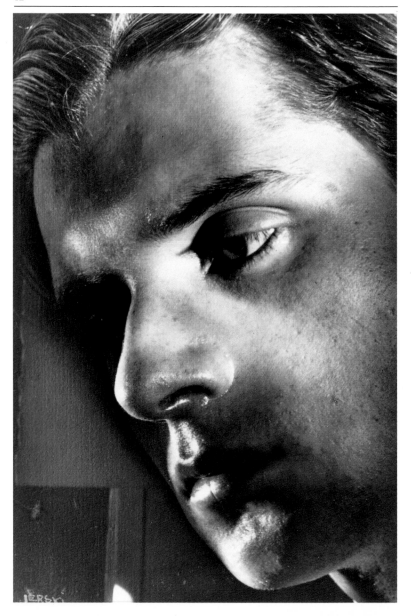

The temptation to see analogies between Bacon's life and work is something that the artist himself has encouraged while at the same time demonstrating its futility. If his painting is, as he declares, a lasting record of his life, it is not a direct reflection – rather an irregular echo, a reworking of lived experience. But every detail counts in a life as extraordinary as Bacon's, whose legendary episodes have fuelled numerous biographies.

CHAPTER 1

TURNING TOWARDS PAINTING

Around 1928 Bacon (opposite) had not yet decided on a career as a painter. And yet this *Composition (Figure)* (1933; right) already shows him, five years later, adapting the free techniques of modern pictorial art to his own purposes.

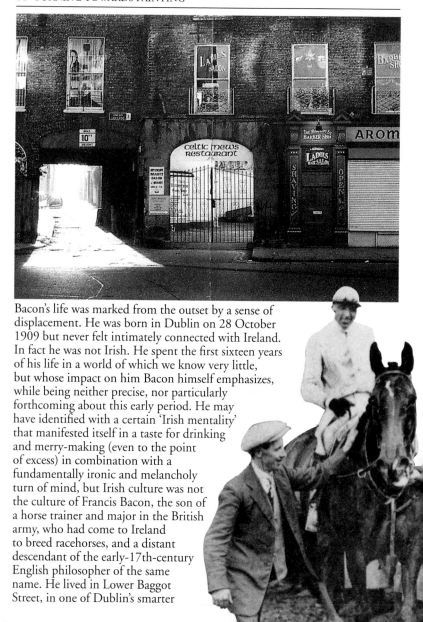

Bacon's life was marked from the outset by a sense of displacement. He was born in Dublin on 28 October 1909 but never felt intimately connected with Ireland. In fact he was not Irish. He spent the first sixteen years of his life in a world of which we know very little, but whose impact on him Bacon himself emphasizes, while being neither precise, nor particularly forthcoming about this early period. He may have identified with a certain 'Irish mentality' that manifested itself in a taste for drinking and merry-making (even to the point of excess) in combination with a fundamentally ironic and melancholy turn of mind, but Irish culture was not the culture of Francis Bacon, the son of a horse trainer and major in the British army, who had come to Ireland to breed racehorses, and a distant descendant of the early-17th-century English philosopher of the same name. He lived in Lower Baggot Street, in one of Dublin's smarter

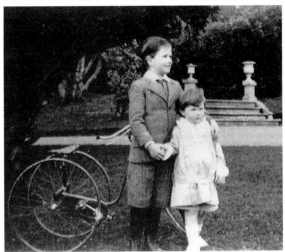

Opposite: a view of Lower Baggot Street, in the southern district of Dublin, and some of its gracious early-19th-century red-brick houses. The second of five children, Francis Bacon (left with his elder brother Hartley) was born at number 63. His family soon moved to the country, where they occupied a series of large houses. Bacon disliked living in the country, though he took refuge willingly enough in the libertarian atmosphere of his grandmother's house.

areas (a few doors from the house where Oscar Wilde was born some fifty years earlier), but was soon to follow his mother and brothers and sisters when his father whisked them off to England or into the heart of the Irish countryside, to County Kildare or the area around Kilcullen, which has a long tradition in breeding horses.

The world as a place of menace

Rather than this relatively unstable home life, it was the atmosphere of tension and violence characterizing the quasi-military environment in which the family lived, together with the Troubles in Ireland and the upheavals of the First World War (when he was living in London), that left their mark on Bacon's childhood. He was often to say that living under the threat of war had been a profoundly formative experience for him. In terms of material comforts – the family houses and the country properties – there was little to complain about, but the young Francis had a difficult relationship

Left: Major Edward Anthony Mortimer Bacon (wearing a trilby) left the British army to breed and train racehorses, immersing himself in the world of racecourses, stables, grooms and horse dealers. Was it this life of petty deals and bets that led Bacon to speak so harshly of his father, describing him as a 'failed horse trainer', or was his judgment based on the bitterness he felt towards a difficult and authoritarian man, who was as irascible with the rest of the world as he was with his own family? Whatever the answer to this, Bacon's father had no sympathy with his son's plans to become a painter.

with his father and little contact with his mother. As he commented to David Sylvester in *Interviews with Francis Bacon*, 1993: 'We never got on. They were horrified at the thought that I might want to be an artist…. I can't say I had a happy home life.' The picture we get is of a child left very much to his own devices, constrained by the atmosphere of stultifying puritanism at home, but free of a regular education, running away from boarding school, isolated by his asthma, more interested in the stable hands than the splendid uniforms and parades his parents no doubt dreamed he would enjoy. Visits to his great-aunts and his maternal grandmother afforded him moments of pleasure in which eccentricity, imagination and art all played their part. At the house owned by his Newcastle aunt, which was said to be almost as big as the Palace of Westminster, Bacon would have seen paintings done by another family member, Charles Mitchell, in the style of the Pre-Raphaelites.

'Off you go, Francis!'

Exposed to all these changes of scene and to a world in which adults seemed so often to act in contradictory ways and adopt contradictory roles, Bacon constructed an identity for himself that was unfettered by conventions and taboos and was to lead to the final rift with his family. In Daniel Farson, *The Gilded Gutter Life of Francis Bacon*, 1993, he describes how 'One day my father caught me trying on some of my mother's underwear. I must have been fifteen or sixteen at the time. He threw me out of the house.' Though Bacon's description may not be entirely accurate, the episode is representative of the way things were. Equipped with an allowance of £3 a week, an independence of mind and a sense of bravado that he held to for life, he set out for London in 1925.

There he sold women's clothes and worked as a domestic employee, and perhaps also as a gigolo,

Young Mrs Bacon, Christine Winifred Firth (left), regarded her son as a 'drifter'. For many years she refused to face up to the fact that Francis was earning his living as a painter.

The Berlin of 1926–7 – 'a wide open city, which was, in a way, very, very violent', as Bacon remembers it – was the scene of great contrasts in social and human terms, and artists bear witness to events of that time in work that betrays their sense of disquiet. While Brecht's *Dreigroschenoper* was playing to music by Kurt Weill and Alfred Döblin was finishing *Berlin Alexander Platz*, Otto Dix – whose work regularly scandalized his public – was depicting the world of depravity that lay behind the city's opulent exterior in paintings like *Homage to Beauty* (1922; opposite top).

frequenting the lowest levels of society and drifting apparently at random as circumstances dictated. It was his father, oddly enough, who gave him the opportunity to assert his identity by entrusting his son's further education to one of his friends. Under this precious new tutelage Bacon was able to take advantage of several months in Berlin, followed by a trip to Paris. In Germany's climate of debauch he learnt to indulge his senses to the full and to cultivate the pleasures, and the vices, of a nocturnal way of life – as captured by the painters Georg Grosz, Otto Dix and Max Beckmann – and to acknowledge his homosexuality.

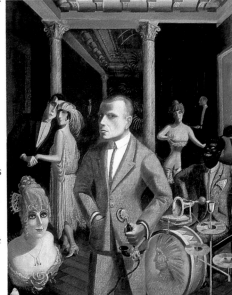

Far left: sketch for *Brigands* (1922) by George Grosz, whose bitter satires exposed the racketeering prevalent in Germany between the wars. Undermined by the crisis of 1929 and the pressures of Nazism, the Weimar Republic was on the verge of collapse. Visiting Germany when he did, Bacon was well placed to assess the situation. As he stood (left) in the grounds of the Schloss Nymphenburg in Munich in 1928, Ireland must already have seemed very far away, and the adult world a pitiless place.

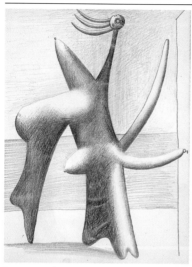

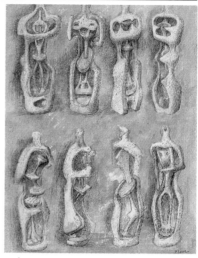

From Berlin to Paris, from life to art

It was the time Bacon spent in Paris, between 1927 and 1929, that marked a major turning point in his life – not simply because it was the start of his lifelong love affair with Paris and his predilection for the French language, which he always spoke in an accent and manner idiosyncratically his own. The paintings that he got to know at this time were to have a formative influence on him: he was fascinated, for example, by Poussin's *Massacre of the Innocents*, which he saw on his visits to the Musée Condé in Chantilly, and a Picasso exhibition at the Paul Rosenberg gallery in Paris provided Bacon's first acknowledged contact with modern art. Although he had not met the Montparnos, whose reputation was already well established, or any other prominent Paris actors, Bacon was beginning to get a sense of the artistic atmosphere of Paris and of the potential for expression through painting. The 19th century offered a rich inheritance alongside more contemporary works: Verlaine's

Above left: a drawing from an album by Pablo Picasso (1928), whose elongated figures and dynamic volumes created shock waves when his work was first shown in Paris. Above right: *Ideas for Sculpture: Internal and External Forms*, a drawing by Henry Moore (1940).

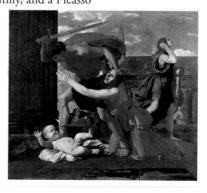

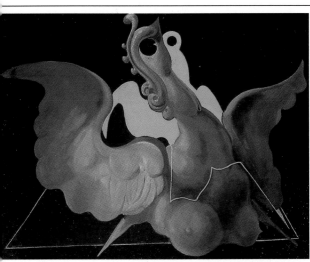

Bacon drew his visual inspiration from the most varied sources. He was fascinated by Poussin's *Massacre of the Innocents* (1630–1; opposite below) and its expression of maternal fear through the woman's anguished cry. And he would have known of other artists' attempts to break new ground: Henry Moore, for instance, was playing with figural dimensions in painting and sculpture and establishing himself as a British avant-garde artist. And Max Ernst's distinctive pictorial universe would have been familiar to Bacon (even if years later he had nothing positive to say about Ernst). Working on the fringes of Surrealism, Ernst was experimenting with new formal approaches and producing figures like this *Chimera* (1928; left), a distant cousin of some of Bacon's own creations. There are similarities – in the suggestion of a historical genesis, the dreamlike atmosphere, the three-dimensional treatment on a flat ground, the geometrical framework and the independence of figure and shadow – but whether this is a case of coincidence or reminiscence is not important: it shows that Bacon's monsters are not just isolated and independent beings.

bohemia, the poetry of Baudelaire (hailed by Bacon throughout his life), the Ballets Russes and the Surrealist flights of fancy of the film director Luis Buñuel (*Un Chien Andalou* was made in 1928). None of this was exactly a source of aesthetic influence: rather, it offered Bacon the opportunity to open his eyes to the world. Besides he was even more interested in the inventions of contemporary furniture designers and architects, people like Charlotte Perriand, Pierre Chareau, André Lurçat, Le Corbusier and Bauhaus designers like Marcel Breuer – so interested, in fact, that he began making a living from, among other things, interior decoration and furniture design. For Bacon, watercolour painting was nothing more than a temptation and he appears to have painted his first oils in the studio he took on his return to London in 1929. He was twenty at the time.

European modernity

Art and painting were uncharted territory for Bacon to explore, and the choices he made at this stage were governed by the immediate context in which he found himself, and more particularly by the European art scene, which impinged on his growing artistic consciousness in a kind of condensed form. He may not have had a formal training, but, as a young artist living

in London between the wars, he was still exposed to a whole constellation of apparently contradictory influences, from Bauhaus to Piet Mondrian, and Pablo Picasso to Max Ernst, and including artists like Henry Moore and Ben Nicholson and all the successors of the British Impressionist Walter Sickert. When Jean Arp, Naum Gabo, Laszlo Moholy-Nagy and Walter Gropius, founder of the Bauhaus movement, fled the Continent at the end of the 1930s their arrival in London signified a substantial boost to the Constructivist inheritance.

And Surrealism, for its part, far from becoming sidelined as a cliquish Parisian phenomenon, generated new formal links and left its mark on the work of artists such as Paul Nash. Surrealism was very much in evidence during the 1930s, at a time when the influence of Impressionism could once more be traced in the work of both landscape painters and progressive, figurative

Above: one of the few surviving rugs designed by Bacon (c. 1929). Below: an article of August 1930 in *The Studio* devoted to Bacon's rug and furniture designs. Modern forms and materials provide the elements of post-Cubist compositions, whose coldness is conveyed by Roy de Maistre in his painting of Bacon's studio (left) from 1930.

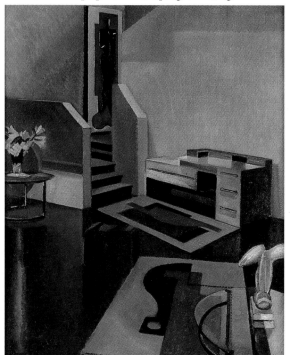

artists with a social or political bias. The career of an artist like Victor Pasmore is entirely exemplary: committed to abstraction until 1936, then again in the 1950s, in the intervening years he adopted a naturalistic approach as a painter of landscapes – a vein he was on the point of exploring, in 1937, the year he exhibited with Bacon.

In Britain more than anywhere else at this time artists were demonstrating the potential for a whole range of aesthetic solutions: a heterogeneity Bacon was to turn to his advantage in creating a universe that at different times has demonstrated its links with formal abstraction and the Surrealist emphasis on the accidental, as well as its attachment to the figurative – a particularly British phenomenon, shared by the other painters with whom Bacon rubbed shoulders from the beginning of the 1930s, and one that was to remain a constant throughout his career.

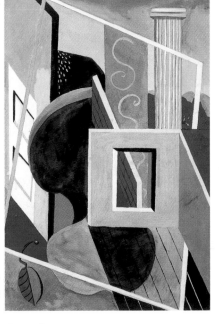

This *Gouache* (above), dated 1929, is one of Bacon's first known works. It combines a multiplicity of perspectives with architectural elements, interlinking structures and an empty landscape reminiscent of Giorgio de Chirico. The white and yellow lozenge in the picture gives it a unity and creates a sense of depthless space. The cages and tubular constructions that Bacon used extensively, much later, were to serve a similar purpose.

A young London decorator tempted by painting

Bacon moved into a studio that had been converted from a garage. His furniture and interior designs, made from ultra-modern materials, received a great deal of comment, even attracting notice in the specialist British press. Bacon met Roy de Maistre, a painter fifteen years his senior who, by an odd coincidence, had also left his horse-breeding family, in his case in Australia. De Maistre was one of those influential figures who appear at

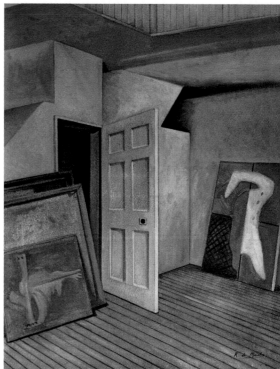

Roy de Maistre remains a relatively unknown figure (in spite of several retrospectives). He had an engaging personality and great sensitivity, and Bacon remained loyal to him for many years. De Maistre produced portraits and still lifes to do with food and a preoccupation with the theme of the crucifixion (he was to execute several commissions for the Church), but also less conventional paintings featuring strange creatures reminiscent of Bacon's own. Works of the early 1930s, at the height of his friendship with Bacon, provide a valuable historical record, as in this view of the studio (in Royal Hospital Road, c. 1934), which demonstrates Bacon's shift towards painting. The portrait below, painted c. 1935, shows Bacon as a young man of twenty-five or so, when he had already painted his *Crucifixion*.

different times in the course of Bacon's life, exercising a variety of roles – as father, brother, friend and rival. Bacon developed a number of strong emotional bonds in which he was both the giver and the taker: he was capable of using people, but along with the selfishness was a sensitivity and an ability to share, an awareness of his attractiveness to others and also a capacity to learn from them. If he was both manipulative and generous, this was just one of the many contradictions that made up his complex personality.

De Maistre provided new openings for Bacon in two different directions at least: in terms of the practice – if not the technique – of painting and in terms of his social relationships. In 1930 the two men exhibited furniture and paintings together, including Bacon's very first canvases. Bacon's studio had been transformed for

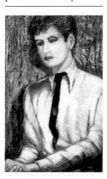

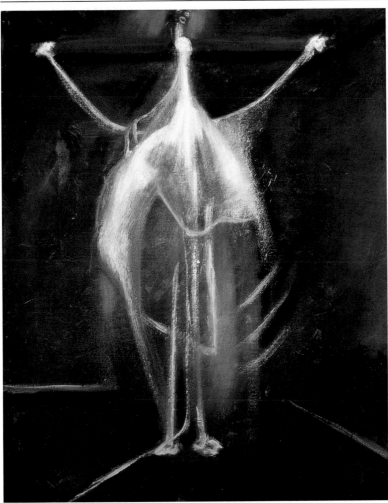

the purpose into what we would today call a showroom. Painting was taking up more and more of his time and, thanks to the support of his friends, he succeeded in making an entry into the art world that might almost have been considered premature: his first outstanding success, entitled *Crucifixion* (1933), was reproduced in a book on contemporary art by Herbert Read, *Art Now*.

Shown and bought at a very early date, the *Crucifixion* of 1933 (above) was one of a series. The other paintings have all disappeared.

Friendships and high living

Artist or interior designer? Bacon had made his choice and would soon give up interior design altogether (later denigrating it in the harshest terms). But life as an artist was not easy and, as his circumstances changed, Bacon was frequently obliged to move studios. He took part in a handful of collective shows, then, in 1934,

ART NOW

AN INTRODUCTION TO
THE THEORY OF MODERN
PAINTING AND SCULPTURE
BY HERBERT READ

FABER AND FABER LIMITED
LONDON 24 RUSSELL SQUARE W.C.1

Crucifixion (1933) was reproduced opposite a Picasso in Herbert Read's book (left), and immediately acquired by a collector, but Bacon knew that he still had to refine his artistic vocabulary and establish his principles of construction (treatment of planes, development of images, etc). The oil paintings *Interior of a Room* (c. 1933; opposite above)

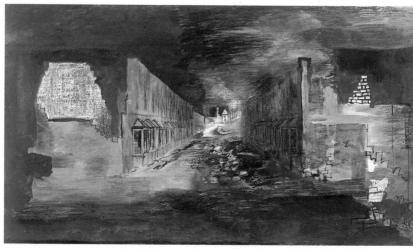

organized his own in the basement of a London house in Curzon Street. Disappointment at his lack of early success meant that Bacon produced less for a while, living largely by his wits, in a bohemian style that threatened to infringe conventional taboos, his energies consumed by one overriding passion: gambling. An inveterate gambler, a bon viveur, no doubt sensitive to what was going on around him and keenly aware of the tensions running through Europe in those pre-war years, but deliberately living on the fringes of society, Bacon forged new relationships and friendships, while

and *Figures in a Garden* (c. 1936; opposite below) show how his artistic intelligence was beginning to mature. Europe was on the eve of war and artists like Graham Sutherland (*Devastation 1941: An East End Street*; above) were being asked to produce works on the theme of war.

continuing to paint. In 1936 one of his paintings was rejected at the International Surrealist Exhibition on the grounds that it was insufficiently Surrealist. There is evidence that he participated in a number of other exhibitions, and that he was, therefore, still working at this time. His paintings were frequently shown alongside Graham Sutherland's. Sutherland, whose reputation was already well established, was another great friend (though the two men were to become rivals) who contributed to Bacon's technical know-how and brought him into contact with various influential artistic milieus. From Eric Hall, his mentor, financial backer and loyal supporter

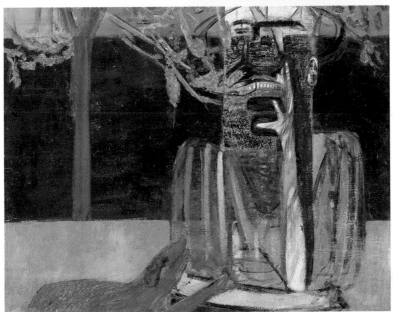

throughout the 1930s, Bacon learnt a savoir-faire that he had scarcely had the time to acquire, so busy had he been living. When war broke out Bacon was declared unfit for active service on account of his asthma, but he did enrol in the ARP (air-raid precautions) defence corps service. Though he was not involved in the fighting, the war was a difficult time for him, a time spent drifting and simply surviving, indulging in gambling and sex.

During this period Bacon lived in the studio that the famous Pre-Raphaelite painter John Everett Millais had occupied in a house that had been bombed. Despite the damage, Bacon was attached to the place and lived there with his nanny, who had stuck by him almost without a break since his childhood. The studio combined a place to work, a secret gaming room and a venue for providing his friends with good food and wine. While the storm clouds were gathering, Bacon once more applied himself to his painting.

As one war ends another begins

The work was really beginning to take shape now, resulting, in 1944, in the massive and enormously powerful triptych entitled *Three Studies for Figures at the Base of a Crucifixion*. Although the triptych may be regarded as a point of reference for Bacon's work as a whole, we know very little about the circumstances leading to the creation of this piece, which was painted as the war dragged interminably to its conclusion and before the full extent of its horrors could be appreciated. As Bacon was to say thirty years later to Sylvester, the studies were designed to stand for 'the usual figures at the base of the cross. And I was going to put these on an armature around the cross…. But I never did that; I just left these as attempts' – as creatures of his imagination, half nightmare, half monument of an age.

Bacon never wanted any of his earlier works to be shown, regarding the triptych as his point of departure, and it is with these three strange monsters on their orange background that the career of this disturbing artist really began. Bacon was thirty-five and for almost the next fifty years without interruption his heightened perceptions of reality would be largely channelled into his work as a painter.

The end of war in Europe was only a month away when the Lefevre Gallery in London was showing works by Moore and Sutherland and other British artists. Also included in the show were Bacon's *Three Studies for Figures at the Base of a Crucifixion*, painted in the previous year. Describing the exhibition, John Russell comments in *Francis Bacon*, 1993: 'Some of them came out pretty fast. For immediately to the right of the door were images so unrelievedly awful that the mind shut snap at the sight of them. Their anatomy was half-human, half-animal, and they were confined in a low-ceilinged, windowless and oddly proportioned space. They could bite, probe, and suck, and they had very long eel-like necks, but their functioning in other respects was mysterious…. They caused a total consternation. We had no name for them, and no name for what we felt about them.' Bacon's creatures mirrored the cruelty of the times and offended a public eager to forget the horrors of war; but for Bacon they were linked to the very foundations of Western culture: title and arrangement as a triptych are based on Christian iconography.

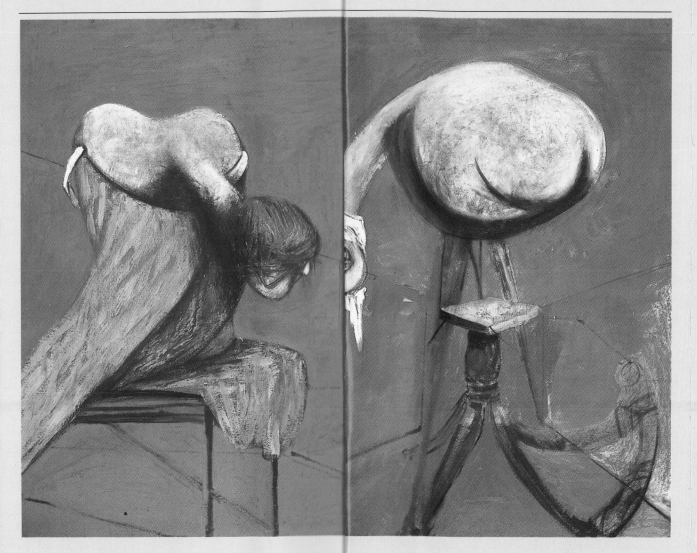

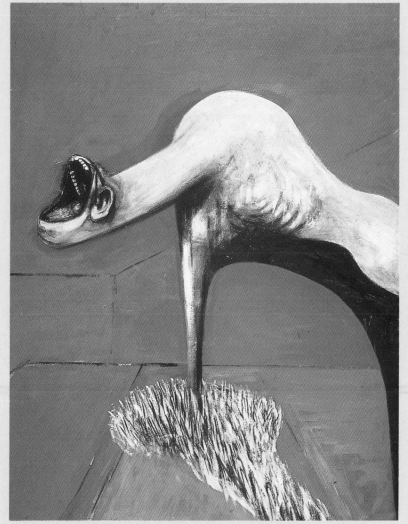

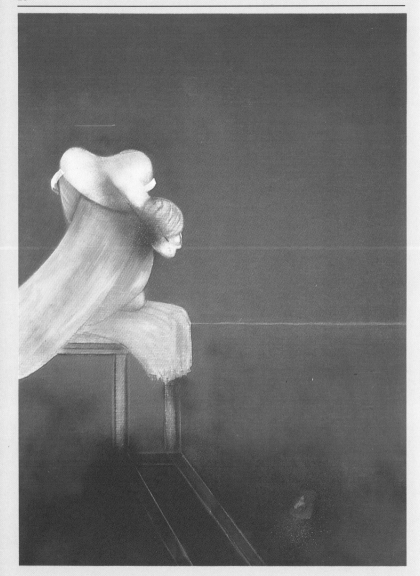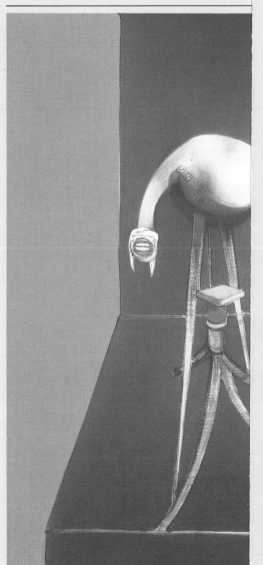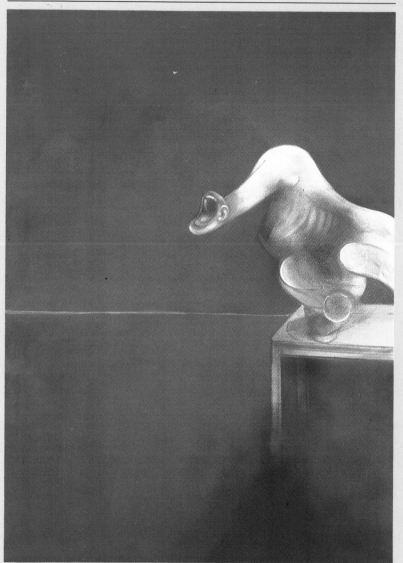

The *Second Version of Triptych 1944*, forty-four years later, reflects a peculiarity that runs throughout Bacon's oeuvre: the fact that he considers each of his works as preparatory studies. It is a description that almost fits the 1944 work, of which Bacon said that he had always wanted to produce a larger version. And the theme of the painting reinforces the notion, since it neglects the image of the crucified figure, representing at most the figures traditionally gathered at the foot of the cross. The absence of the central figure contributes to the complexity of the crucifixion theme, which is both omnipresent and constantly skirted. In the second version the sharper treatment has reinforced the hardness of the figures but reduced the menacing quality of the surrounding space, in particular through the application of that vibrant red to the bare canvas.

Bacon, looking sombre and withdrawn (left), sits in the sunlight in the garden of his cousin Diana Watson in 1942. It was thanks to her that several paintings of the 1930s were saved from destruction by the artist.

Should we see Bacon as part of the British traditions of landscape and portraiture? A descendant of Constable and Turner, of the notion of landscape as sensory and experiential rather than descriptive? Inheriting the sensitivity to line and light of a Gainsborough and the vigour of a Hogarth, and proceeding as far as caricature? Perhaps, despite himself, they are the bedrock upon which the density of his colours and the cruelty of his vision are based.

CHAPTER 2

CREATING AN OEUVRE

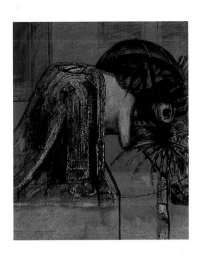

After the war Bacon (opposite; 1950s) devoted himself entirely to his studies, including the *Figure Study II* (right) of 1945–6. Resonant colours, vaguely human characteristics and banal accessories are combined in this painting.

For Bacon the consecration of his art was a gradual process, effected by a peculiar mixture of casualness and tenacity. A regular succession of shows, the contrasting critiques of detractors and enthusiasts, and the commitment of a handful of loyal supporters all contributed to the recognition that his paintings soon won.

The stables of success

There was a huge gulf, however, between the Olympian heights to which history was to ascribe him a place and the studio in South Kensington, then a run-down area of London, in a particularly unimposing building that had once been stables. Bacon moved there in 1961 and kept the studio for the rest of his life. Few people ever set foot inside, particularly when the artist was at work, and the place – known largely through photographs – assumed an almost mythical status, becoming famous for its cramped conditions and the awkwardly steep staircase (which led up to both the studio and the living areas), the numerous tools and assorted objects that piled up there, the books and torn-out illustrations, and the colour tests daubed on the walls – the improbable forcing ground of a talent that was soon to be widely recognized.

Although attentive to his international success, Bacon disdained social recognition if, for example, it took the official form of decorations and other distinctions. When he was offered such distinctions he refused them

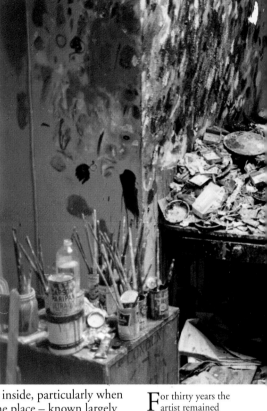

For thirty years the artist remained faithful to his studio (above; in the 1950s), turning it into a world of painting, a den of legendary chaos. Pots, brushes, rags and illustrations lay all over the floor; the door and walls were used as a palette; the mirror was spotted with mildew, and one bare light bulb hung from the ceiling.

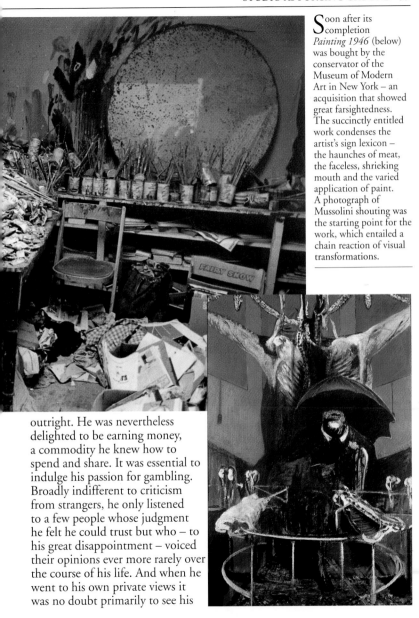

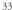

Soon after its completion *Painting 1946* (below) was bought by the conservator of the Museum of Modern Art in New York – an acquisition that showed great farsightedness. The succinctly entitled work condenses the artist's sign lexicon – the haunches of meat, the faceless, shrieking mouth and the varied application of paint. A photograph of Mussolini shouting was the starting point for the work, which entailed a chain reaction of visual transformations.

outright. He was nevertheless delighted to be earning money, a commodity he knew how to spend and share. It was essential to indulge his passion for gambling. Broadly indifferent to criticism from strangers, he only listened to a few people whose judgment he felt he could trust but who – to his great disappointment – voiced their opinions ever more rarely over the course of his life. And when he went to his own private views it was no doubt primarily to see his

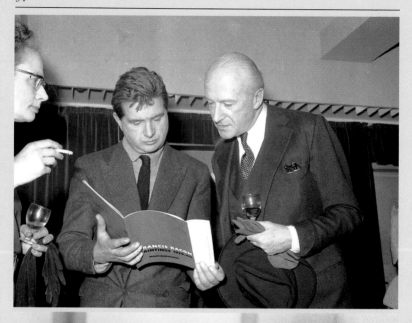

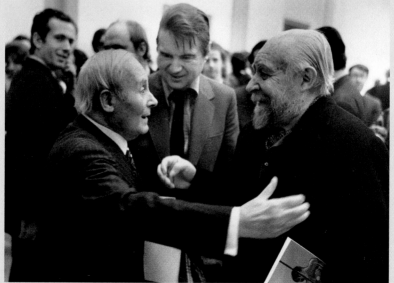

First retrospectives

Bacon's first one-man exhibition in a London gallery was held in 1949. Shows followed in New York in 1953 and Paris in 1957. In 1954 Bacon took part in the Venice Biennale with Ben Nicholson and Lucian Freud and each year that followed brought another exhibition. Bacon enjoyed attending the previews, behaving charmingly and appearing happy. His first retrospective was held at the Tate Gallery in 1962. Others followed at the Guggenheim Museum, New York, in 1963, and at the Grand Palais, Paris, in 1971 (opposite below: with Joan Miró and André Masson), before a return to New York in 1975. At the exhibition in the Rue des Beaux-Arts in Paris in 1977 the police had to be called in to control the crowds. Bacon's work was shown in Tokyo in 1983, England and Germany in 1985 and 1986, Paris again in 1987 and Moscow in 1988; then, after his death, in Lugano and Venice in 1993, at the Fondation Maeght in 1995 and the Pompidou Centre, Paris, in 1996. Left: at the Galerie Lelong, Paris, in 1987. Opposite above: with Cecil Beaton in 1960 at Marlborough Fine Art.

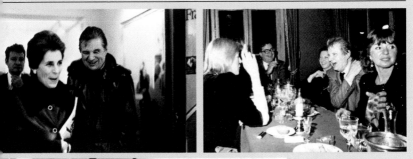

The socialite

For a time at least Bacon's works fetched higher prices than those of any other contemporary European artist. He always left the dealers to look after his financial affairs and from 1948 he was represented by the Hanover Gallery in London, where he had a loyal supporter in its owner, Erica Brausen. Then in 1958 Marlborough Fine Art took over from the Hanover Gallery. With branches in London, New York and Tokyo, the Marlborough enjoyed an international reputation that was indispensable to Bacon at this stage of his career. It is still principally responsible today for safeguarding the interests of his oeuvre. Opposite and above: Bacon in Paris in 1971, 1977 and 1984. Main picture: posing for photographers in Paris in 1987.

paintings in a way that was scarcely possible in the cramped conditions of his studio.

Building up a body of work: a life of unremitting effort

The only rule Bacon imposed upon himself was constantly to test and re-test the results of his efforts. It was by wrestling with his materials and subtly verifying the achieved effects through

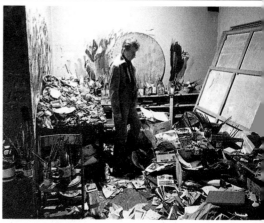

direct experience – and by these means alone – that he would succeed in building up a body of work. And he refused to allow himself a moment's respite until a painting was completed to his satisfaction – or, failing that, destroyed. His dissipated lifestyle did remarkably little to diminish the energy he devoted to his work, which imposed relentless demands in terms of sheer regularity and continuity. We know that Bacon worked every day, starting at six in the morning and finishing at noon. We also know that he adopted a deliberately haphazard method of searching for images, setting the stakes high and aiming for an outright success, which left no room for mistakes and resulted in the destruction of numerous canvases. The whole of his work is underpinned by this one simple strategy, which has far more to do with the artist's attitude and his commitment to the act of painting than with the cultural origins of his art. That is not to say that Bacon's work is free from cultural influence: on the contrary, his work is shot through with it, but cloaked in different forms. It is for this reason that Bacon's oeuvre lacks any real sense of a progression or of problems overcome, though it has its hiccoughs and crises; it proceeds without major breaks or re-evaluations, characterized by moments of anguish, but also by a relentless determination, taking up the same themes in a way that undermines any notion of linearity or chronology.

●I'm greedy for life; and I'm greedy as an artist. I'm greedy for what I hope chance can give me far beyond anything that I can calculate logically. And it's partly my greed that has made me what's called live by chance – greed for food, for drink, for being with the people one likes, for the excitement of things happening. So the same thing applies to one's work.●

Francis Bacon in
David Sylvester
*Interviews with
Francis Bacon*, 1993

Above: Bacon in his studio.

It remains for the spectator today to find his bearings in a visually coherent universe that is, in many cases, easily recognizable.

Precisely for this reason, however, it is important to move beyond the initial impact of the work, its shock effect, in order to pay attention to the remarkable pictorial intelligence it embodies. Each canvas poses questions about the nature of painting, as if the questions had never been asked before.

'Everything that I do goes into painting'

Such a passionate exercise of his art cannot have failed to affect Bacon's personal life. And yet the links between his life and his work are far less clearly defined in terms of cause and effect than is the case for

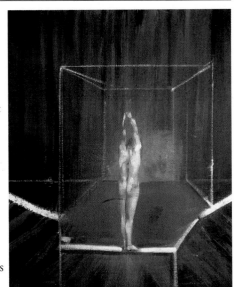

many other artists. From the moment he started painting it was the painting that influenced and directed the course of the artist's life, his friendships and travels. Almost every aspect of his personality had been determined by the end of the war: his creative impulses, his lifestyle and the nature of his emotional attachments. Bacon frequently used his close friends as models, and his whole artistic vocabulary originates in lived experience. He gave us a

The male nude made its appearance in Bacon's work in the early 1950s, forcing itself on to a cultural scene where even female nudes were a rarity. In *Study of a Nude* (1952–3; above) a diver is about to plunge into a bottomless space marked out by a geometric structure; outlines are smudged and the light diffused by the soft brushwork. The *Study of Figure in a Landscape* (1952; left) shows a very different figure – sitting with his knees tucked up, facing forwards, in a natural landscape – but both landscapes, night and day, are impressionistic rather than descriptive.

key to understanding his work when he declared to
Sylvester in 1975: 'Everything that I do goes into
painting' and when he describes himself – with typical
self-mockery – as a cement mixer, which churns things
up in such a way that it is difficult to see what went
into the mix once it comes out again.

Family in Africa, friends in Soho

After the death of his father in 1940 Bacon's love-hate
relationship with his family came to an end and contacts
between them dwindled. In burying his father, Bacon
was also burying Ireland. Twice, in 1950 and 1952,
he was to visit his mother and sisters, who had made a
new life for themselves in South Africa. These were no
doubt valuable trips in the sense of helping to foster the
idea that his family history was continuing ... without
him; but they also introduced him to Africa, whose
landscape and wildlife were to exert a lasting fascination
for Bacon.

His social life was concentrated around a handful
of locations, in addition to the studio-flat in South
Kensington. On the one hand, there were the galleries
and museums that Bacon was to frequent for years
during afternoon walks that he took in order to see
everything. There was also the London of Chelsea
and Soho, and their clubs and pubs.

A world in miniature, rowdy and dissolute

In the post-war years Soho formed a microcosm in
which artists, journalists and writers destined to live
markedly different lives were busy trying to shake off
the spectres of war. Alcohol, homo-
sexuality, but also art, poetry and
the daily elements of living were
the stakes in a game played by the
most varied types of people. It was
an environment in which Bacon
stood out. The abundant references
to his wit and the spicy stories
in which he played a part feed a
legend, which, even when it has a
positive bias, does not always help
us to gain access to his painting.

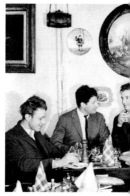

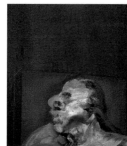

M*iss Muriel Belcher*
(1959; below)
was one of Bacon's first
named portraits. Below
the portrait: model and
artist in conversation.

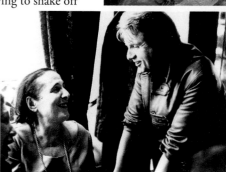

Bacon frequented the Colony Room Club, the French Pub, Gargoyle and various restaurants, his favourite being Wheeler's, and these were much more than simply public places, so closely were they bound up with his habits, his private world, so much a part of his daily life.

Muriel Belcher, the manageress of the private Colony Room Club, was a colourful character whom Bacon painted many times and whom he often described as his best friend.

Left: Bacon and friends enjoying a meal at Wheeler's, c. 1962. From left to right: Timothy Behrens, Lucian Freud, Bacon, Frank Auerbach and Michael Andrews. The photograph was taken by John Deakin, a privileged observer of many such occasions. The large canvas *The Colony Room* (1962; below), painted by Michael Andrews, captures some of the

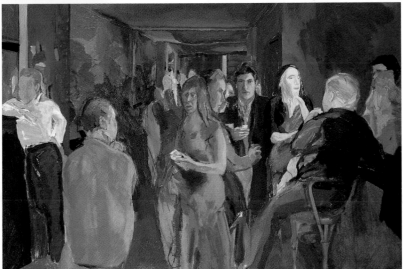

Bacon had an account at Wheeler's, a fact that was not insignificant, since he was in the habit of footing the bill for many of the banquets consumed at his table. And the owner, who felt particularly warmly towards Bacon and his friends, preferred to throw out respectable customers rather than curb the provocative remarks and rude behaviour of his faithfuls.

In Soho there were museum curators and critics like David Sylvester, who was to publish a collection of

atmosphere of the club. Muriel Belcher is standing at the bar (to the right of the picture) and the figure immediately to her right, with his elbow on the counter, may be Bacon himself.

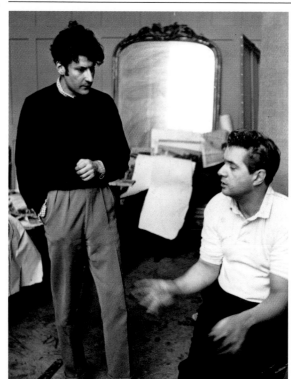

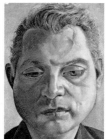

For Lucian Freud and Bacon, seen here in conversation in Bacon's studio in 1953, the roles of artist and model were interchangeable. Freud's portrait of Bacon (1952; above) was stolen in transit between London and Berlin in 1988. Bacon always spoke highly of the work – a rarity where Freud's paintings were concerned. The two men had been close friends since they first met around 1943 and their friendship was extended by a shared preoccupation with the human figure. Freud, grandson of Sigmund, readily expressed his admiration for Bacon's work. Bacon was not in the habit of acknowledging debts, but since he never wasted his time criticizing works that did not interest him his severity regarding Freud should be seen as a form of recognition.

famous interviews in which Bacon speaks with great intelligence about his work. Belonging to the art world, however, was not the best visiting card: whoever you were, you had to gain acceptance, or fade from the picture, and Bacon could be all too quick to make scathing remarks. There were young folk who were attracted by this shifting society; there were also birds of passage. And there was the photographer John Deakin, a prickly character who often did shots and portrait photographs for Bacon. Soho also had its share of writers, collectors and society people who rubbed shoulders with London's bohemian population.

London School or 'Muriel's Boys'?

But above all there were Bacon's artist friends: Robert Colquhoun and Robert MacBryde, whose work passed

largely unnoticed; John Minton, a painter of some renown who was busily squandering his fortune; Graham Sutherland, for a time; and those whom history has collectively dubbed the London School – Lucian Freud, Frank Auerbach and Michael Andrews. The term is hardly appropriate if one assumes from it a correspondence with the Paris School and the existence of a coherent aesthetic. It relates, rather, to a period in the lives of a group of artists who were active in the 1950s and exchanging ideas as friends do; although they had little in common from an aesthetic point of view, the artists of the London School did in fact occupy the

Bacon criticized Freud for his expressionism, which in his view came too close to a type of illustrative humanism. Bacon painted without his model being present, whereas Freud required his model to pose for him while he worked. From 1951 onwards Freud's face and body, rolled up into itself, appear some forty times in Bacon's work.

Isabel Rawsthorne, photographed by John Deakin (left) and painted by Bacon in *Three Studies for Head of Isabel Rawsthorne* (1965; below), was another of Bacon's friends and models. An artist and single woman, she led a life full of incident. She lived in Paris and posed for André Derain and Alberto Giacometti (whom Bacon greatly admired and eventually met), and her face, bearing and personality all combined to make her one of the great female figures in Bacon's life.

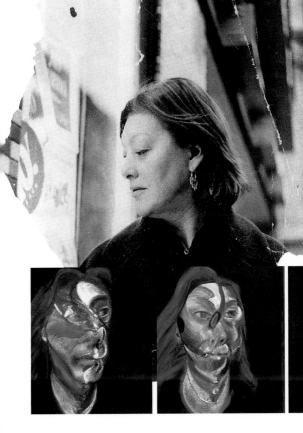

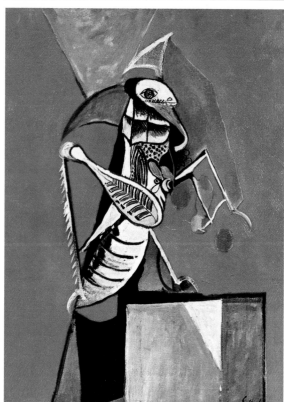

forefront of a certain artistic scene in England at that time. The 'London' part of the title had only incidental significance, since Frank Auerbach and Lucian Freud were originally from Berlin, Leon Kossoff was the son of an immigrant and Bacon had grown up in Ireland; Kitaj was an American, and the most English of the group, Michael Andrews, described himself as having no roots at all. In those post-war years, while the wind of existentialism was blowing on the Continent, the London School was primarily concerned with individual expression. Other artists were continuing to develop an approach based on a critical awareness of everyday life, a trend that was to find expression at the end of the 1950s in the work of Richard Hamilton and in Pop Art.

Bacon met Graham Sutherland in 1937. Convinced of his friend's extraordinary talent, Sutherland was to prove enormously supportive, despite the gulf that existed between them in terms of social background and lifestyle and the fact that Sutherland, with a solid artistic training behind him, had already established his reputation and accepted a professorship when Bacon was just starting out. Sutherland gave Bacon endless recommendations without fearing his ingratitude. The two artists spent a great deal of time together during the war and in the 1950s, sharing extended holidays in the South of France, on the Côte d'Azur, where they discussed art, techniques and themes that interested them both at the same time. For Sutherland, influenced by his early work as an engraver, the attention to line was paramount (as in *Cigale I*, 1948; left). Around 1946 Bacon was, meanwhile, discussing his attempts to achieve a new kind of technical synthesis that would convey a sensation directly to the nervous system via the paint alone. The bitter feelings provoked by Bacon's success were eventually to undermine their friendship.

Landscape near Malabata, Tangier (1963; left) is one of Bacon's rare landscapes, a genre with which he felt ill at ease. He only painted landscapes when, as he said, he felt incapable of producing figures – from which we may infer that he regarded landscape as an inferior subject: he was more interested in representing people. His travels provided the rare occasions when Bacon tried his hand at the genre: in the South of France during the 1950s; in South Africa in 1950 and 1952; and above all during his trips to Morocco. Bacon was introduced to the charms of Tangier by his friend Peter Lacy and on his frequent visits there between 1956 and 1960 he met William Burroughs, Allen Ginsberg and Paul Bowles, writers of the Beat Generation, and artists and other figures who had severed their ties with Europe. *Landscape near Malabata, Tangier* was painted from memory, after Bacon's return to London, and can barely be said to be descriptive. Executed away from the bright natural light of Morocco (in which Bacon found it difficult to paint), the intense, swirling colours create the effect of patches of paint rather than a recognizable image.

Bacon may have vehemently rejected abstraction (an ongoing subject of debate since the 1930s) like his London School friends, and shared with them an attachment to the historic dimension of art, but the importance he attributed to the image in painting radically distinguished him from other members of the group. The temptations of descriptive painting – landscape in Andrews' case, portraiture in Freud's – and of an attachment to the expressive dimension of the pictorial material (as in the case of Kossoff and Auerbach) found only the most distant echo in the art of Bacon, the eldest and undoubtedly the freest of them all. Referring to those years, Daniel Farson prefers to speak of 'Muriel's Boys' rather than the London School.

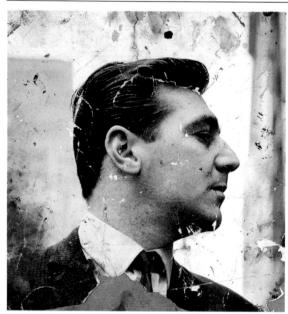

Special friendships

The most important people in Bacon's life were, of course, his partners and models: Peter Lacy, from 1953 to his death in 1962; George Dyer, whom Bacon met in 1964; and John Edwards, the companion of the last twenty years of his life. Curiously enough, the high-points in the artist's career coincided with moments of crisis in his relationships. Peter Lacy, who had been ill, died the same night as the private view of Bacon's first retrospective, at the Tate Gallery. George Dyer was another black angel hovering over the painter's life. Capricious and prone to depression, he was regarded as an uncouth companion for Bacon, but embodied a kind of strength that the artist sought repeatedly to capture on canvas. Dyer committed suicide on the day before the private view of Bacon's Paris retrospective, in 1971, creating a sombre counterpoint to Bacon's success.

During the 1970s and 1980s places changed: the London of the 1980s had an entirely different atmosphere from that of the 1950s. As he grew older Bacon

Bacon painted George Dyer's body and profile several dozen times after the two men met in 1964, and long after his precious model's death. The triptych *In Memory of George Dyer* (opposite) appeared in 1971. The central panel, with its rare effect of depth suggested by the staircase, recalls the Paris hotel where Dyer committed suicide. The figure about to pass through the door is disappearing into its own shadow, while a naked arm reaches up to insert a key in the lock. The mirror portrait in the right-hand panel, based once again on Deakin's photograph (left), gives the model two Janus-like heads facing forwards and backwards. In the left-hand panel an aerial structure merges with the convulsed body of a man whose ambiguous posture hovers uncertainly between pain and pleasure. For Bacon Dyer was the incarnation of a masculinity that combined tension, energy, mobility and instability. Central to the artist's relationship with his model was a powerful emotional charge that Bacon was to explore repeatedly, trying to go ever further in understanding it.

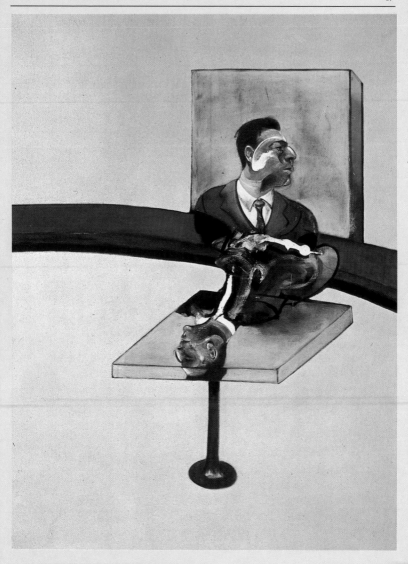

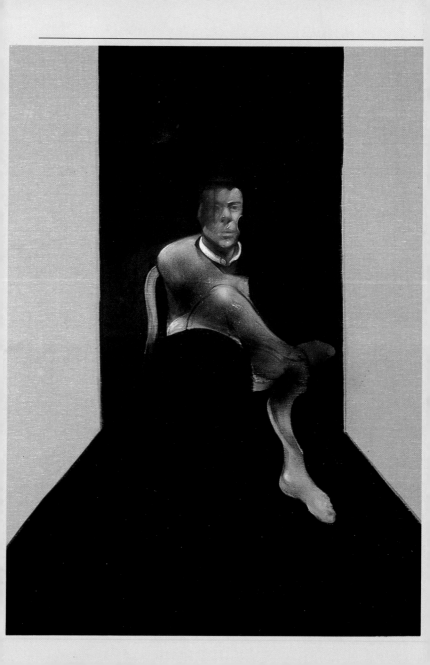

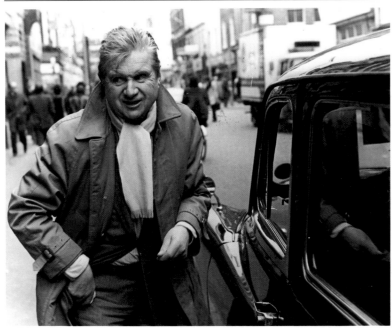

continued to enjoy dinners with friends, parties and trips to the country. His studio was always waiting for him, however, especially at the approach of his exhibitions. These followed close upon one another, providing both an opportunity to travel and the best incentive to keep on working.

'Clear away one or two of the veils or screens'

Every member of the artist's circle of friends had one thing in common: sincerity. Bacon was an astute and accurate judge of character, capable of indulging weakness, but not dishonesty. As he saw it, painting was an experience transmitted directly via the nervous system and only painting enabled us to probe truths. In 1973 he remarked to Sylvester: 'We nearly always live through screens – a screened existence. And I sometimes think, when people say my work looks violent, that perhaps I have from time to time been able to clear away one or two of the veils or screens.'

In 1974 Bacon (above) met John Edwards (centre panel), the East End lad who, we are told, could neither read nor write. In *Study for Portrait of John Edwards* (1986; far left) and the work of the same title (1988; near left), as in the small triptych (1980; centre panel, top), the treatment of the figure results in a fusion of paint effects rather than a distortion. Meanwhile, Bacon's appetite for life continued. He once said to Sylvester: 'I think of life as meaningless; but we give it meaning during our own existence.'

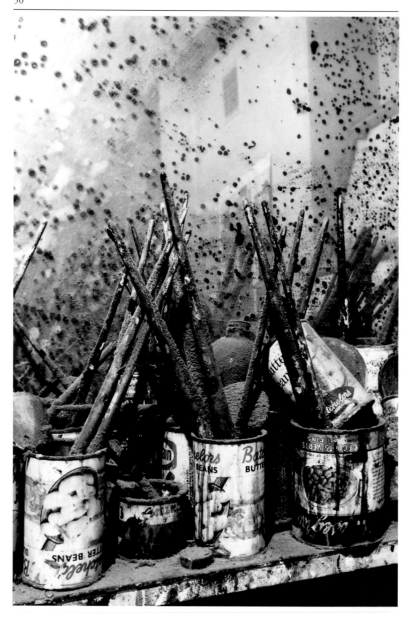

In contrast to many modern painters whose work was conditioned by a reappraisal of their language, method and support, Bacon remained astonishingly constant in his choices, perhaps because he had conquered rather than learnt them. The transformations – which inevitably took place in almost fifty years' work – did not in any way contradict his original options: the use of oils and the painting as an image trap, designed to capture its reality.

CHAPTER 3

'A MAKER OF IMAGES'

‘How do I feel I can make this image more immediately real to myself?’ asks Bacon. The painting is much more than a simple reflection in the studio mirror (opposite): it uncovers the reality of the image. Right: *Study for Self-Portrait* (1982).

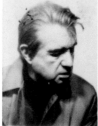

Central to Bacon's practice is the importance accorded to the image: the image of the body (which resulted in an approach that was virtually unique); the image as a condition of seeing and a link with reality; the image as raw material, the starting point of painting.

Image as evidence

The image is as clearly distinct, for Bacon, from abstraction (and the merely decorative function from which abstraction can never entirely escape) as from imitative, analogical, descriptive representation, which he rejects as illustration. What Bacon understands by image is the instantaneous evidence that immediately transmits itself to the brain without the need for verbal intervention. It is his means of coming, as he said to Sylvester, 'immediately on to the nervous system', of cultivating instinct and irrational comprehension, an understanding through synthesis. This is where his work begins, freed from the logic of resemblance, and seeking to touch much more closely on reality, a process of exploration based on instinct.

Bacon described to Sylvester how 'images just drop in as if they were handed down to me. Really, I think of myself as a maker of images. The image matters more than the beauty of the paint.' A mental image fed by the memory of things seen and by aspects of existing images, resulting from a state of awareness in which the unconscious played its part (even if Bacon was cautious in his use of the term), a form of waking dream, as he also described it. The image in Bacon's paintings may appear transformed, distorted, fragmented, exaggerated, split, broken up, fragmentary and complex, but its purpose is nevertheless to serve as a form of evidence. Bacon was profoundly attached to the figurative tradition, but

•I loathe my own face, and I've done self-portraits because I've had nobody else to do. But now I shall give up doing self-portraits,• Bacon declared to Sylvester in an interview in 1975. The impetus for Bacon's self-portraits began with that fascinating image-making machine the automatic photo booth. The artist kept entire strips of such photographs (left and below), in which he cultivated a total lack of expression, adopting improbable poses that appear to have been largely dictated by the wish to avoid looking at himself. The strange format of the *Four Studies for a Self-Portrait* (1967; opposite) is reminiscent of the photographic strip.

at the same time quite unafraid of shocking his audience. His preferred material remained, of course, the human figure, but his treatment of the image was unique: Bacon was 'only' an artist, but, he admitted to Sylvester in 1975, 'perhaps if I was very young I would be a film-maker; it's a most marvellous medium'.

'His' realism

It is this treatment of the image that Bacon – fully aware of the historical weight of the word – refers to as 'his' realism, despite the gulf that separates Bacon's realism from the realism of a painter like Courbet, whom he nevertheless claimed to admire. Bacon's approach is resolutely modern, concerned with the reality of the vision and of the perceptive experience rather than with the imitation of visual appearances. He carves out a path for himself between the mire of decorative abstraction – which either wallows in the exclusive celebration of texture or loses its way in an ill-defined vocabulary of forms – and the trivial concern with illustration, of which photography is the queen and ordinary figurative painting the mere lackey.

From his experience of abstraction Bacon had retained an interest in the architectural aspects of a painting and a freedom with regard to backgrounds. In the abstract painting the image gains from being able to appear in a space that has no need (or only a minimal need) of referring to space as we know it: colour and a few lines build up the necessary references.

As for illustration, the other great threat, Bacon drew on its resources – using photographs and other printed matter as a kind of dictionary of forms – in order ultimately to distance himself more effectively from it. It was only at the end of

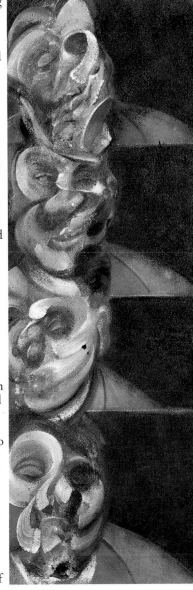

the process that he arrived at 'his' realism – a realism divested of description that seeks to take 'reality by surprise', as John Russell puts it, and discover resemblance through distortion. It was through the latter, as Van Gogh had shown him, that the painting came closest to reality and to an accurate recording of it. In an interview with Sylvester Bacon praised Van Gogh: 'And Van Gogh is one of my great heroes because I think that he was able to be almost literal and yet by the way he put on the paint give you a marvellous vision of the reality of things.'

It was the creatures of *Three Studies for Figures at the Base of a Crucifixion*, in 1944, which launched the first

Three Studies of Isabel Rawsthorne (1967; below) brings together three images of the model in a scene set, as it were, in a multiple timescale. The painting manages, however, to avoid introducing a narrative (as Bacon was anxious to do), a proposition that was harder to achieve where more than one figure was involved. Here he solves the problem by

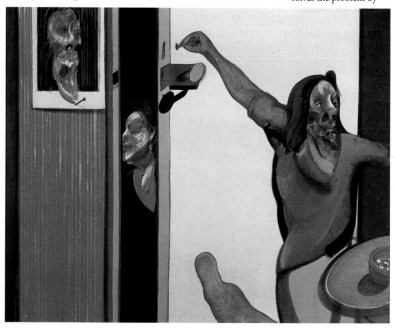

of such profound attacks on the image and sent the first shock waves reverberating through the art world. And the attack continued in various forms: in many paintings from the 1960s onwards it occurs when the image is reduced to secondary status as a photograph, painting or reflection.

placing the three portraits on separate planes and creating separate types of image: hence the passage of day to night from one side of the door to the other.

The image within the image

In *Three Studies of Isabel Rawsthorne* (1967) the interplay of the three images includes a photograph of the model pinned to the wall, and in *Three Portraits: Posthumous Portrait of George Dyer, Self-Portrait, Portrait of Lucian Freud* (1973) an additional black-and-white image appears at the back of two of the panels. Electioneering posters serve in place of photographs in *Triptych 1974–7*, while *Four Studies for a Self-Portrait* (1967) is modelled on a photo strip from the sort of automatic photo booth of which Bacon was so fond. The photographic image, the act of photographing and the camera itself are all representational material, like the painting in the background of *Two Studies for a Portrait of George Dyer* (1968). Image-screens, defining the empty space of the canvas, they serve the same purpose as the blinds recognizable from their cords in *Three Studies for a Crucifixion* (1962). The painting within the painting can also appear in the form of a fragment of decor – *Study for Bullfight No. 1* (1969) or a monumental effigy *Triptych 1976* – but is most clearly identifiable at the centre of a painting like *Three Figures and Portrait* (1975), where it manifests a solid human presence.

Reflected images, for their part, enable the artist to introduce additional elements into the composition and to distort the image in various ways. With the *Triptych Inspired by T. S. Eliot's Poem 'Sweeney Agonistes'* of 1967 the mirror gives an altered reflection of the scene before

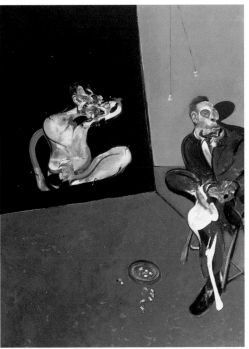

Two Studies for a Portrait of George Dyer (1968; above) brings together the model and the artist's portrait of him in Bacon's studio. This was another of Bacon's ways of multiplying a figure within the painting (without creating a storyline) while exploring the personality of his model through the effect of a double image that conveys the transient nature of psychological states.

it, as if mirroring a separate moment, while in *Study of Nude with Figure in a Mirror* (1969) the lateral figure reflected in the mirror assumes a peculiar role as observer of the scene. Whether the reflection lacks a visible model, as in *Lying Figure in a Mirror* (1971) or produces a distortion between the figure and its image, as in *Portrait of George Dyer in a Mirror* (1968), we learn more about the reality of the image from its multiple disassociated states than we could learn from mere illustration.

More often than not the image is 'in-between', slipping into the painting space through a half-open door or by a leap of logic, a visual paradox, rather than appearing directly. The image remains the foundation for all Bacon's paintings, more or less easy to identify depending on its treatment and the multiplicity of its sources, which range from scientific imagery to photographs of news items, from the paintings of the great masters, seen or reproduced, to photographic portraits, and including elements from day-to-day life: any kind of image can provide raw material for a painting, since Bacon sees his identity as based on 'this peculiar kind of sensibility as a painter, where things are handed to me and I just use them'.

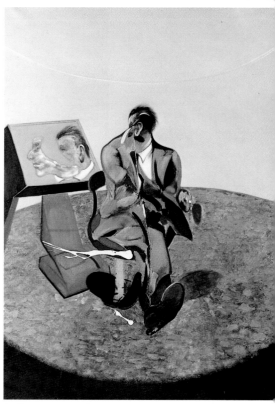

In the *Portrait of George Dyer in a Mirror* (1968; above) the doubling effect, achieved through reflection, is repeated in the split images of face and body: the model's body is fractured, caught in a twisting movement as it turns to avoid the sight of its broken face. The painting appears to be holding a dynamic situation in a state of blurred suspension.

Influences

Early in his career commentators of his work and the artist himself began organizing an inventory of

references – an endless task, but in any case Bacon (who referred to himself as a 'pulverizing machine') had sufficiently averted his viewers to the looseness of interpretation and the multiplicity of readings to which his paintings lent themselves.

When asked, as he frequently was, which artists he liked and who had influenced him, Bacon declared his enthusiasm for Egyptian art and the rock art of northern Spain, for Cézanne, Degas, El Greco and Goya, Renoir to an extent and Seurat. He had little time for Anglo-Saxon art, though he admired Shakespeare, Dylan Thomas, Yeats and T. S. Eliot. With very few exceptions he was also scathing about his contemporaries, including Paul Klee, Jackson Pollock and Jasper Johns. When it came to painters who had influenced him – both old masters and modern artists – Bacon often saw very clearly the reasons that linked him with these artists.

Picasso is undoubtedly the artist with whom he claimed the closest affiliation. The Spaniard's fidelity to the human form and his determination to distort it, his freedom with regard to construction and his technical

curiosity – all had an impact on Bacon, especially the Bacon of the early period that has virtually disappeared without trace. The theme of the crucifixion may have originated with Picasso. But for Bacon this choice of theme has more to do with the immediacy of the image than with its symbolic associations: there is no religious feeling

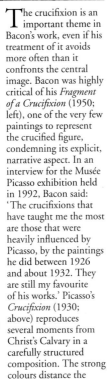

The crucifixion is an important theme in Bacon's work, even if his treatment of it avoids more often than it confronts the central image. Bacon was highly critical of his *Fragment of a Crucifixion* (1950; left), one of the very few paintings to represent the crucified figure, condemning its explicit, narrative aspect. In an interview for the Musée Picasso exhibition held in 1992, Bacon said: 'The crucifixions that have taught me the most are those that were heavily influenced by Picasso, by the paintings he did between 1926 and about 1932. They are still my favourite of his works.' Picasso's *Crucifixion* (1930; above) reproduces several moments from Christ's Calvary in a carefully structured composition. The strong colours distance the observer from the story.

in Bacon's work (as the artist himself frequently reminds us); the image of crucifixion simply exerts a formal attraction through its structure – its verticality and centrality – over and above its cultural significance. And yet, though he was to paint several crucifixions, very few of them actually focus on the structure of the cross. In his 1944 painting Bacon avoids the central image altogether, concentrating instead on figures at the foot of a crucifixion, as if what rapidly came to interest him was not so much the theme as the architecture of the painting – the triptych arrangement frequently used in sacred art to depict the scene of Christ's death. The structure of the cross with the body attached to it scarcely appears in Bacon's work at all, except in *Fragment of a Crucifixion* of 1950. The paintings of 1962 and 1965 and the 1988 version of the 1944 triptych revolve around a threefold arrangement that owes little to religious iconography, except in so far as it represents flesh – or meat – which, in Bacon's terms, is the essential dimension.

Images of raw flesh

It is this cruelty that interests Bacon: a cruelty reinterpreted by artists down the centuries until it has become a commonplace of our culture. His preoccupation with bare flesh, with wounds and gore, is what links Bacon with sacred art, with Matthias Grünewald, for example, whose Isenheim Altarpiece (1512–6) showed religious imagery at its most ghastly, using the complex arrangement of the polyptych.

Two other artists – profane, rather than religious, this time – influenced Bacon's vision of flesh, animality and death: Rembrandt, whose *Carcass of Beef* (1655) was the first attempt of its kind to focus on animal subject matter in painting; and Chaim Soutine, who plunges headlong into a visceral style of painting whose raw violence is held in check by his use of colour. (Bacon prided himself on the fact that neither he nor Soutine had undergone any formal training.)

The side of meat became one of Bacon's key motifs. In *Painting 1946* and its second version, painted in 1971, and in *Figure with Meat* (1954) and *Carcass of Meat and Bird of Prey* (1980) the animal structures gradually

In the triptych *Three Studies for a Crucifixion* (1962; opposite) several motifs are connected through the simple repetition of the uniformly coloured space (a room perhaps) that encloses them. Bacon's responses to Jean Clair's questions about the painting are somewhat elusive. '"To get back to the crucifixion. Do you think that you can add something new to a scene that people have been representing for almost two thousand years?" Bacon: "I think it's stupid to try, but I still like one of the images from the 1962 *Crucifixion* ... the right-hand panel." Clair: "But it's more than a crucifixion, it's almost a scene of slaughter, butchery, mutilated meat and flesh." Bacon: "Well, that's all the crucifixion was, wasn't it?"' The sides of meat, the two figures and the mangled body on the bed are echoed in other paintings of his. The right-hand panel, which he says he particularly likes, mirrors in reverse the outlines of *The Crucifixion* (1272–4) by the Florentine painter Giovanni Cimabue. Of Cimabue's figure Bacon said to Sylvester: 'I always think of that as an image – as a worm crawling down the cross.'

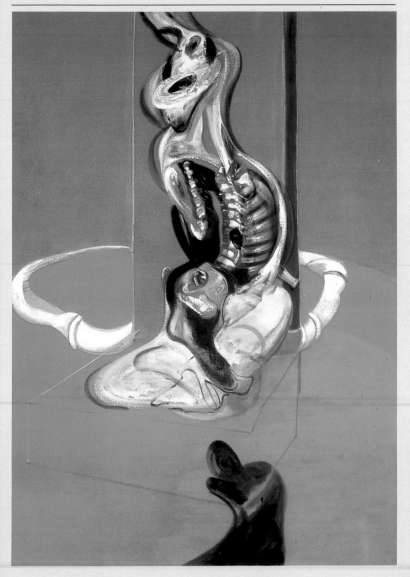

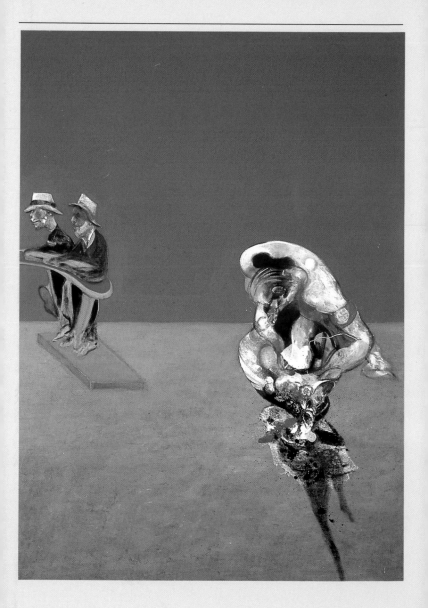

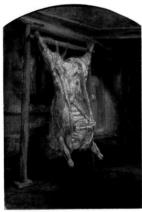

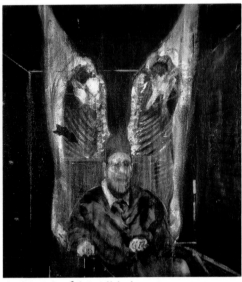

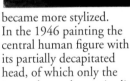

became more stylized. In the 1946 painting the central human figure with its partially decapitated head, of which only the jaw and mouth remain, links the portrait of the political orator or despot (the microphones are visible in another version of the painting) with the crucified carcass in the upper segment. Here, then, are executioner and victim: the man in black with his props ranging from the strange to the banal – the open umbrella that leaves him in shadow and the guardrail enclosing him on his rostrum; and the dead flesh reminiscent of gruesome news images, horror films and the butcher's stall.

An obsessive iconography

With its repetitions, its distortions, contaminations and reinterpretations Bacon's iconography is an obsessive affair, mingling the nightmarish, the anthropomorphic and the ludicrous and moving between grandiloquence and mockery, abjection and terror.

Rembrandt opened up a new direction in painting for Bacon with his portraits and self-portraits, his 'irrational marks' that 'record a fact', as Bacon put it. Here again the structure of the image is simple, centred. The face itself becomes a piece of theatre and takes its meaning from its position at the heart of the painting space. Bacon's series of *Heads* (1948–9) are built up by

This triptych (opposite), entitled *Crucifixion*, was painted in 1965. The figure on the right wears an armband decorated with a swastika, a detail that has encouraged a historical reading of the work. Two men watch a naked woman dancing. Hanging in the central panel is a pathetic stylized figure, roughly recalling the right-hand panel of the 1962 triptych, while in the left-hand panel a slaughtered body is lying on a bed. Like Rembrandt in his *Carcass of Beef* (1655; above left), Bacon had focused on the sensational aspect of raw meat in *Figure with Meat* (1954; above right).

distortion, from the central point of the open mouth and the silent scream issuing from it.

Bacon also borrowed from Velazquez, whose portrait of Pope Innocent X (1650) inspired some forty variations, which Bacon was later to describe as a failure and a source of regret. This deep dissatisfaction with his work was a recurring feature throughout his career and led him to destroy numerous paintings.

Bacon's interest in the portrait by Velazquez reveals something about his attachment to reproductions, to photographic models, even when the model in question was the subject of a painting. With the help of his friends Bacon acquired every book he could find containing a reproduction of the painting, becoming addicted to the search. But when the opportunity arose to see the original in Rome he let it pass. It is tempting to draw a parallel with another of his direct models: Van Gogh. In 1957 Bacon painted a series of variations on Van Gogh's *The Painter on his Way to Work* or *The Road to Tarascon* (1888), which marked an important stage in his development. The paintings displayed a new freedom in terms of colour and brushwork, widening the artist's pictorial language and reinforcing the

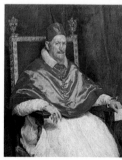

Velazquez's *Pope Innocent X* (1650; above) fed Bacon's visual imagination, leading to the series of *Popes* after Velazquez (from 1951), but also facilitating the transformation of the *Heads* (*Head VI*, 1949; below left) into portraits (*Study after Velazquez's Portrait of Pope Innocent X*, 1953; below right).

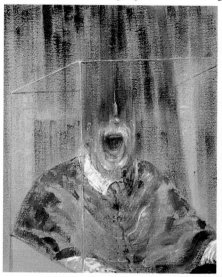

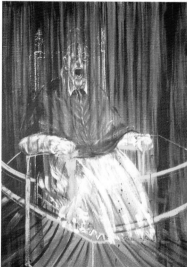

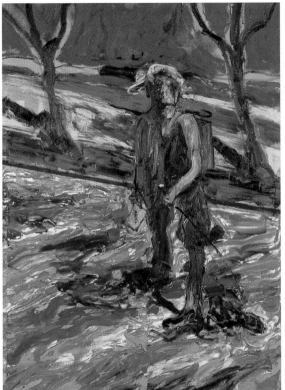

In 1957, with a one-man show almost upon him, Bacon launched himself into a series based on a reproduction of Van Gogh's *The Painter on his Way to Work* or *The Road to Tarascon* (above), producing seven paintings, including *Study for Portrait of Van Gogh III* (left), *II* (below) and *Van Gogh in a Landscape* (bottom).

possibilities for distortion through his handling of the paint. But here again the painting lesson was taught via reproduction – and for good reason: the Van Gogh in question had been destroyed during the Second World War and only existed as a photographic image. It was as if photographic representation facilitated access to and 'use' of the old masters by reducing the inimitable painting to an image.

The photograph as a visual springboard

Photographs provided Bacon with an inexhaustible source of material, helping to equalize the status of the painter's various visual stimuli and to distance the elements of his dictionary of images. This distancing

process is demonstrated by the special relationship Bacon entertained with his living models, from the time of his first named portrait – that of Lucian Freud in 1951. This and the innumerable portraits of friends that followed – *Miss Muriel Belcher* in 1959 and all the portraits from the 1960s to the 1980s – were painted in the absence of his models, even when these were close friends. Bacon never painted in the presence of another human being, keeping a photograph by him instead, sometimes being obliged to commission it from the capricious John Deakin, part of the Soho set. This did not meant that Bacon painted *from* photographs, even less that he painted photographs themselves: the photograph served simply as a visual springboard, like all those other images that cluttered up his studio – medical illustrations, for example, from the handbook describing diseases of the mouth that Bacon had brought back from Paris in the early 1930s, or the images in a book about X-ray photography.

The artist's studio was a visual universe teeming with photographic images that had been mishandled, torn, trodden on, pinned up, and were periodically renewed – reproductions of his own paintings, press cuttings and pages torn out of books: a photograph of the Nazi

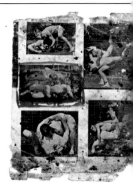

Left: part of the studio wall in 1950, showing some of the elements in the artist's visual dictionary. Images jostled at random: press cuttings, reproductions of works of art (*Christ Carrying the Cross* by Matthias Grünewald, Rodin's *Thinker*), a photograph of a hippopotamous taken from Marius Maxwell's *Stalking Big Game with a Camera in Equatorial Africa* (1924), scenes of rioting and illustrations torn from *The History of British Film 1896–1906* (1948). Above: photographs taken from Eadweard Muybridge's *The Human Figure in Motion* (1887) showing naked men wrestling. Muybridge's albums provided poses that Bacon was to use in very different contexts, as in *Two Figures* (1953; opposite above) and *Two Figures in the Grass* (1954; opposite below), which shows the lovers in an ambiguous space.

leaders Himmler and Goebbels, Baudelaire by Nadar, photographs of riots, and of various well-known figures, film stills (from Eisenstein's *Battleship Potemkin*, among others) and pictures of wild animals.

Inventing movement with the camera lens

And there was another source of inexhaustible wealth of a scientific or at any rate not strictly artistic kind in the photographs of Eadweard Muybridge – some 4700 images assembled under the title *The Human Figure in Motion*, (1887), with almost as many devoted to the animal kingdom. In the 1880s the American photographer was tracking the movement of bodies to a 1/6000th of a second, extensively documenting the human figure in a scientific fashion to produce a study that was detached and methodical and free of idealization. Muybridge's images provided a direct source of material for a number of Bacon's paintings, as in *After Muybridge – Woman Emptying a Bowl of Water and Paralytic Child on All Fours* (1965), which takes elements from several of the photographer's sequences and combines them in a pictorial context that is almost a scene painting. Bacon's dogs of 1952 and 1953 are also derived from Muybridge, and he produced several versions of Muybridge's wrestlers, including *Two Figures* (1953) and *Two*

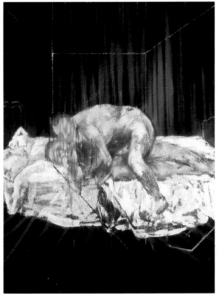

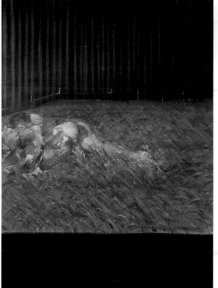

Figures in the Grass (1954), which transform the sporting activity into a sexual embrace. The wrestlers made their final appearance in the *Triptych – Studies of the Human Body* (1979), where they are featured in the central panel.

Muybridge's images also influence, if more subtly, the poses of other figures and bodies that may be fragmented or truncated in movement, and perhaps more obviously the intermingled bodies in *Study of a Man and a Woman Walking* (1988) – more than thirty-five years after the first works 'after Muybridge'.

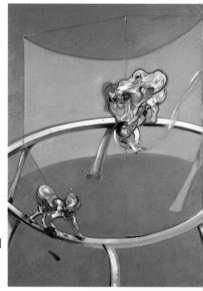

A matter of painting above all else

'Even after defining his principal visual and literary sources,' according to Michael Peppiatt, 'we are still a long way from unravelling the mystery that gives Bacon's work its extraordinary vitality.' Bacon's oeuvre cannot be reduced to a series of images, either borrowed, inspired or invented, or even a series of themes and recurrent figures: it is linked to the specific conditions that make it the work of a painter, a work in which the physical reality of the paint assumes paramount importance. This is the concrete basis upon which Bacon builds 'his' realism.

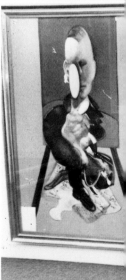

Bacon himself may have drawn inspiration from photographs, but those who only see his work in photographic form fail to evaluate its physical reality and the demands this imposed in painting terms – fail to take account of the dimensions of the paintings, and the effects of scale on the relationship between real and painted space. Bacon was again remarkably consistent in this respect. In thirty years of painting he usually chose one of two formats – 35.5 × 30.5 cm (14 × 12 in.) or 198 × 147.5 cm (78 × 58 in.): a constancy that was not merely the result of accident or convenience.

Scale and formats

The human dimensions of Bacon's large-format works facilitate the relationship between the viewer and the

painting, enabling the artist to work on a large scale (despite the constraints imposed by his narrow, awkward staircase) without becoming over-theatrical. Working face to face with his painting, Bacon could reach the entire surface of the canvas as it stood on its easel. He paid particular attention to the triptych, an arrangement that opened up new possibilities in terms of construction despite the regular dimensions of the works.

The small-format paintings combined into triptychs are reminiscent of the traditional triple mirror that reflects an image from different angles, like the mug shots used by the police to identify criminals. With the large-format triptychs, where each panel is a metre and a half (nearly five feet) in width, framed separately and set a few fingers' width apart, the effect is that of the wide-angle view provided by a cinema screen.

The triptych or the motionless story

In the cramped conditions of his studio Bacon was forced to paint the panels of his triptychs one after

The relationship between the body and the pictorial space, but also between the pictorial space (hence the painting) and real space, was something that absorbed much of Bacon's energies. In the strange *After Muybridge – Woman Emptying a Bowl of Water and Paralytic Child on All Fours* (1965; opposite) two figures drawn from different series in the photographer's work maintain their balance purely through the dynamism of the pictorial language. Posing in front of his *Triptych 1976* (below), Bacon demonstrates the scale of his large works.

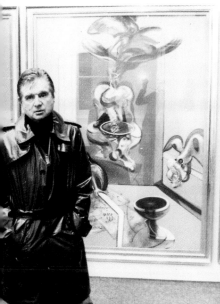
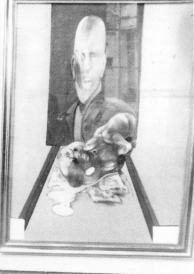

another or, at best, in pairs, transferring just a few reference points from one to the next, constructing his triptychs according to principles of unity rather than strict continuity or uniformity. There is a false symmetry in them: images are caught up in a balancing act and appear to be looking at one another; what unites the triptychs is a visual principle such as a line, a horizon, a particular colour, or the relationships between the figures. But we are a long way from the Christian narrative of the crucifixion, the traditional subject of the triptych; in Bacon's work the triptych becomes a support for a motionless story, a snapshot, a complex mesh of possibilities through which the spectator constructs his own path. This was already the case in the *Three Studies* of 1944, with its monstrous creatures each isolated against a unified acid orange ground and bearing an expression both terrifying and terrified. This association of the three Furies, ancient Greek spirits of darkness and vengeance, and the Christian iconography of the crucifixion carries no significance beyond the actuality of the figures within the context of the painting.

It was many years later, from 1962 (with *Three Studies for a Crucifixion*), that the triptych really took off for Bacon; he was to paint around thirty large examples. It was only with *Triptych Inspired by the Oresteia of Aeschylus* in 1981 that he openly acknowledged his debt to Aeschylus, first of the great tragedians of Antiquity. Over the years the triptych had expanded its terms of reference and become a key feature of Bacon's work.

The painter's constantly reinvented territory: from the boxing ring to the colour field

Bacon explored several other means – apart from questions of format – of constructing a pictorial space that would be uniquely his own. The large paintings of the 1980s display – and this is one of the clearest signs that his work was changing and evolving – a marked contrast between the tortured paint effects of his figures, where the paint is nevertheless thinly applied, and the increasingly uniform ground, the flat expanses of strong colours, echoing the oranges of his early years: pinks (*Oedipus and the Sphinx after Ingres*, 1983), yellows

Study of the Human Body (1982; above) is almost a monochrome, except for the outline of a 'door', which creates a framework for the figure, the base and the tiny scene it supports. The brilliant orange-red of the ground recalls the 1944 triptych, as does the structure supporting the figure. But here the pedestal is unpainted, left 'in reserve'. It is colour – and the absence of it – that composes the universe of the creature, a man reduced to a pair of buttocks, legs and penis, kitted out in a pair of incongruous cricket pads. Bacon told Sylvester in 1974: 'I've increasingly wanted to make the images simpler and more complicated. And for this to work, it can work more starkly if the background is very united and very clear…. I would like the intimacy of the image against a very stark background.'

(*Study from the Human Body*, 1986), mauves, intense reds, colours that border at times on decorative elegance but at times also aspire to a form of dramatic neutrality. (Bacon also repeatedly resorted to leaving areas of the canvas unpainted.)

There had been numerous stages in the development of the relationship between ground and figure, however, during the evolution of Bacon's oeuvre. The series after Van Gogh, painted in haste prior to an exhibition in 1957, mark a clear turning point. Bacon had previously covered the entire area of the canvas with a thick layer of paint which he compared to the skin of a hippopotamus. The figure was to appear out of the solid darkness of the paint, as if drowning in the body of the painting, and the *Heads* of 1948–9 are half emerging, half engulfed in paint as thick and dense as an animal's hide. The colours are generally sombre and the figure is centred in the cramped, dark space: it seeks and finds a small source of light and tries to pierce the darkness, to break through the curtains and veils that prevent it from emerging into the daylight as a fully formed body (*Study for a Nude*, 1951). Bacon

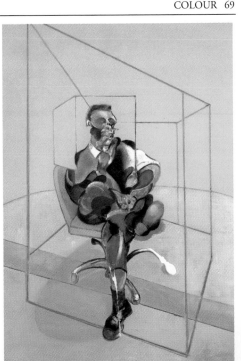

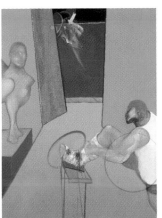

The yellow ground and transparent cages of *Study for Portrait* (1971; above) form a series of interlocking spaces that allow the figure to be observed from multiple viewpoints. The superimposed colours and lines construct a space that is strictly a mental projection, and neither clearly interior nor exterior. In *Oedipus and the Sphinx after Ingres* (1983; left), the flat expanses of pink form a constructed space that opens, via a simple door, on to a strangely inhabited night scene.

made occasional use of colour during these years, but it was only with the studies after Van Gogh that the painter's personal language and the universe he was constructing for himself found definitive expression in terms of colour: the carefree brushstrokes of the Van Gogh studies displayed the same uninhibited energy as the experiments undertaken by the Fauves. Above all, thanks perhaps to Van Gogh, or to his manner at least of situating his figures in the landscape, Bacon began placing his figures on a surface that was particular to them, putting ground beneath their feet. From this point on his figures began to appear on a clearly demarcated surface – a ring or a track, an arena, a floor or a stage – that became a permanent feature of his work at the start of the 1960s.

A demarcated area, an interior non-place

A spectacular variant of this theatrical stage appears in *Triptych – Studies of the Human Body* (1970) and in *Three Studies from the Human Body* (1967), where the figures maintain a fragile equilibrium, poised on narrow bars, tightrope artists venturing on to mysterious apparatus whose rails are suspended in the void. As at the circus, or at a stadium, the scene opens out towards the spectator, who watches the show from a slightly raised viewpoint. This impression of perspective created through the representation of floor and carefully marked-out arena is largely responsible for the sense of enclosure and confinement that critics have identified as one of the major characteristics of Bacon's work – one that is all the more effective for being suggested rather than described.

This demarcated area has a whole vocabulary of signs associated with it. For a long time Bacon was incorporating those transparent 'cages' and other structures that divided up the canvas and enclosed the figures, multiplying the possibilities for recentring the image. Where, in the 1950s, the artist had used mainly black, colour now began to take over and extended the structures in which he continued to place his figures. The bases of these structures were often merely suggested and the uprights similar to the posts of a metal bed.

The beauty of the triptych was the way it allowed Bacon to develop three separate images simultaneously. *Three Figures in a Room* (1964; opposite) was one of the first 'secular' triptychs, painted between the crucifixions of 1962 and 1965. The empty ground, stripped of colour and texture and suggesting infinity, is set behind a tilted surface where the brushstrokes are more readily visible. This is a world reduced to first principles, suggesting the landscape of some alien planet or the barrenness of a stage painting in a modernist adaptation of Shakespeare. Time is suspended and the knotted bodies, fused with their seats, are like pieces of sculpture. The left-hand figure on his white lavatory seat (Bacon mischievously said that the white had to be dazzling) is a trivialized version of Rodin's *Thinker*. In the centre an armless chair, black as the night, both encompasses and rebuffs the figure, who seems to be moving in several directions at once – falling and turning left and right simultaneously – while the right-hand figure is caught in a spinning motion (a pose often reserved for Freud), hovering on the edge of the set, as if recoiling from the drop.

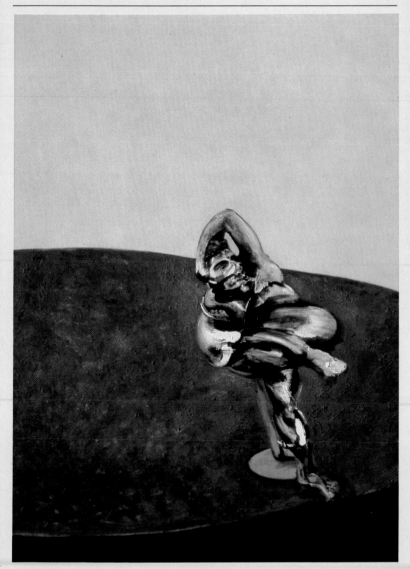

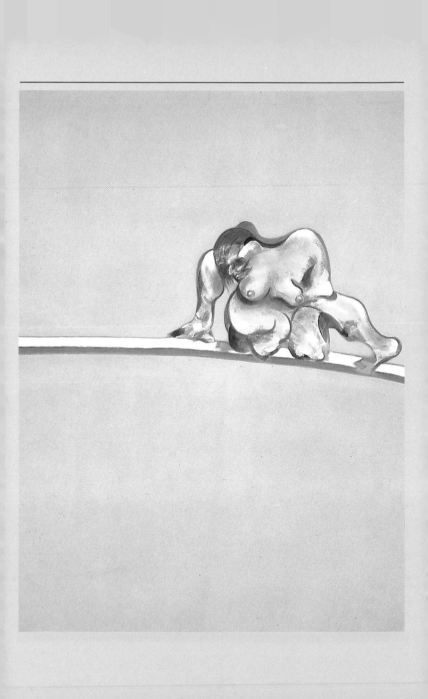

He soon began introducing descriptive elements in a systematic way – a door, a ceiling light, a switch, an incidental plane of colour, a window; various types of seating, from the Pope's lavish throne to the humble lavatory seat (which reappears on several occasions); various sofas; beds accommodating the bodies of lovers and the dying: the banal furnishings of modern life, all contributing to the formation of a mental universe.

This interior non-place, with its characteristic signs, tends towards abstraction in the portraits, whose strictly monochromic grounds form an abstract psychic space, and in a painting like *Study for Head of George Dyer and Isabel Rawsthorne* (1967) the background colour permeates the figures themselves, spreading into the gaps and transparencies of the faces.

At the opposite extreme landscapes continued to exercise an attraction, even if very few of Bacon's works strictly fit into the genre. Landscape included natural landscape, the South of France and Morocco (*Landscape near Malabata, Tangier*, 1963), and landscapes where the focus is on an animal figure, like *Elephant Fording a River*, painted in 1952 on Bacon's return from South Africa. It also included the urban landscape, seen as the Cubists had viewed it and

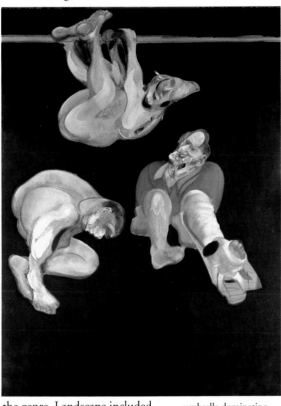

Triptych – Studies of the Human Body (1970; opposite) shows three very obviously female figures doing tightrope acts in a pinkish mauve haze, the central figure with her umbrella dominating the scene. And three athletes are similarly engaged in *Three Studies from the Human Body* (1967; above), in which time and space are suspended.

furnishing the structural components necessary to the composition, as in *Portrait of Isabel Rawsthorne Standing in a Street in Soho* (1967). The isolation of the figure is in no way diminished in this last painting, or in that other street scene that mingles interior and exterior, *Statue and Figures in a Street* (1983). And disconcerting, geometrically structured 'landscapes' return in 1978 with the strange painting entitled *Landscape*, which suddenly seems to veer off into space, and with those curious object lessons *Jet of Water* (1979) and *Sand Dune* (1981 and 1983). Bacon allowed himself these occasional departures in terms of subject matter, and what makes these works stand out from the rest of his oeuvre is the absence of human figures.

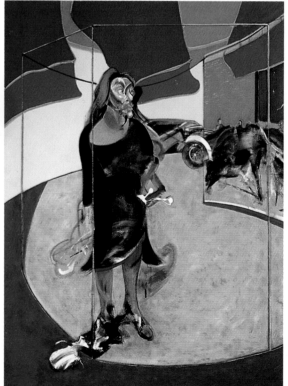

In *Portrait of Isabel Rawsthorne Standing in a Street in Soho* (1967; left) the space referred to in the title has been highly condensed. We see part of a car, vague architectural elements, a few passers-by, a scene sectioned off in a glass cage at ground level, but everything seems to depend on the central figure, who reconstructs the world around her. It is this world rather than the figure herself that is moving. Bacon typically distorts his model's face, emphasizing the arch of her eyebrows and the hollow of her cheeks, but he is kinder to her body (which he rarely painted). One wonders if this indulgence was in any way connected with Bacon's boast in *Paris-Match* that he and Isabel Rawsthorne had been lovers.

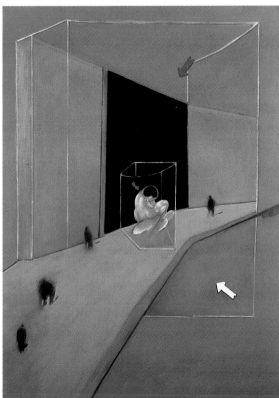

From street to room, from colour field to interior architecture and the objects that furnish it, Bacon always creates an encompassing space, an unstable universe, with an ill-defined horizon, where the principal reference points are often in doubt: with the loss, or rather unreliability, of such signposting, spaces become ambiguous, simultaneously sheltering and menacing, and the only certainty lies in the overall movement of the paint and the individual brushstrokes. The sporting image of the ring and the violence associated with it accurately describe the literally combative way in which the artist engages with the paint, for each painting constitutes a new match.

Bacon was not comfortable painting landscapes. The urban landscape in *Statue and Figures in a Street* (1983; left) and the seascape, if the term can be used to describe *Sand Dune* (1983; opposite above), are still characterized by the use of glass cages, and arrows to indicate movement. The dune overflowing its frame resembles a living body and seems to be driven by a movement whose source is as much organic as meteoro-logical. Any certainty that this is an external scene is undermined by the ceiling light. The urban landscape on its orange ground reduces description to a road running alongside windowless facades and disappearing into the distance, its course interrupted by the outline of a rectangular frame. The street is peopled with ghostly figures, half human, half monkey, and a 'statue' is located in the centre of the composition. This monumental nude, the focal point of the painting, seems to be a throwback to a sculptural project that Bacon had never succeeded in realizing. 'I have decided to make a series of paintings of the sculptures in my mind and see how they come out as paintings,' he declared to Sylvester.

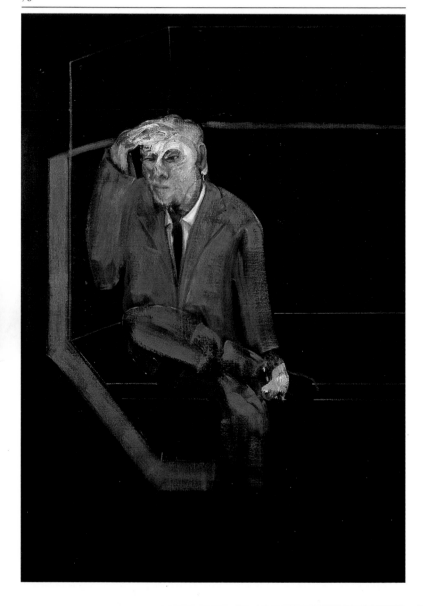

The artist's reservoirs of words and images were now full; the trap was set. For Bacon it was a question of seizing – and not just representing – the essential reality expressed by bodies in movement – those of the painter and those of his models. *Sometimes* painting can reach the senses directly and succeeds, as no other medium can, in trapping the 'reality of the subject matter'. It was this *sometimes* for which Bacon felt compelled to try.

CHAPTER 4

UNLOCKING 'THE VALVES OF FEELING'

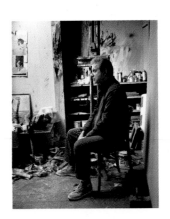

•In a way, it becomes more difficult [to paint]. You're more conscious of the fact that nine-tenths of everything is inessential.• This *Self-Portrait* (left) and the photograph of Bacon (right) demonstrate an essential truth: painting was a matter of waiting.

The stakes were set and the rules in place: all Bacon had to do now was begin playing. Absorbed by his work in the way that a gambler is absorbed by the game, Bacon gambled even when he was painting, introducing an element of accident and chance into the exercise of his art. In the course of teaching himself how to paint he had forged his own set of principles, in which traces remained of the Surrealists' automatism and the gestural painting of the 1940s and 1950s, from the lyrical abstraction of European artists to American 'action painting'. These are links that Bacon himself fiercely denied, particularly with regard to Abstract Expressionism: he believed neither in expression, nor, as we have seen, in abstraction. He had no time for artists like Jackson Pollock and was hardly less scathing about Willem de Kooning; and draughtsmanship, in his eyes, was a skill to be avoided since line drawing locked an element of premeditation into the painting, turning it into illustration in Bacon's sense of the term. He used his brush to set down the initial components of his figures, components arising out of the original impetus

•Why paint for yourself? Not just so you can say: "How clever I am!" But to find a way of seizing what is transitory.•
The image-time correspondence in the paintings is sometimes

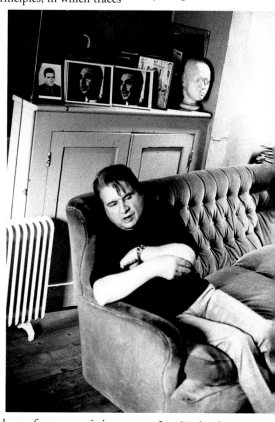

for the image and regularly drawn from pre-existing images. And from then on he worked swiftly, leaving little opportunity for changes of heart, corrections or reworkings, which would create too layered an effect and inhibit the sense of immediacy he was seeking. In an interview with Sylvester in 1973 Bacon remarked: 'I do,

reflected in the relationship between the artist and his surroundings: in 1973 he is unstable on canvas (opposite) and on his sofa (above).

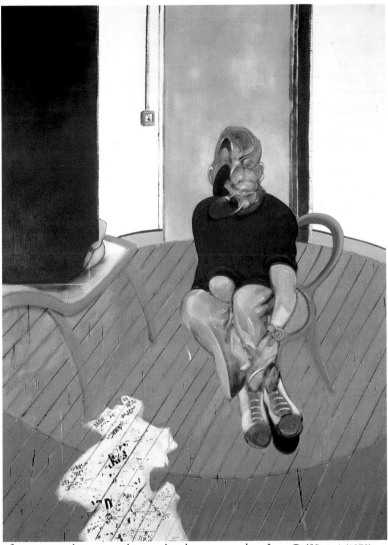

of course, work very much more by chance now than I did when I was young. For instance, I throw an awful lot of paint on to things, and I don't know what is going to happen to it…. I throw it with my hand. I just squeeze

Self-Portrait (1973). A crumpled daily becomes synonymous with daily life.

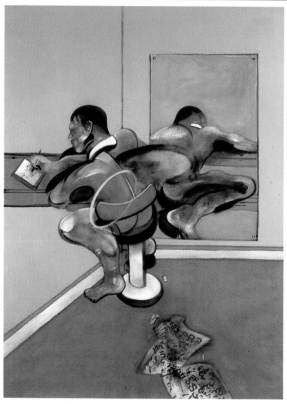

Bacon often commented on what he saw as the tenuous relationship between language and reality. In *Figure Writing Reflected in a Mirror* (1976) he misuses the alphabet, casually transferring letters from mechanical plates to form completely unrecognizable words. The letters themselves are stiff and foreign-looking in the context of the painting, belonging to a different reality from the central image. The reflection in the mirror is relatively independent of its model, but remains linked to it by a mysterious arabesque – wound or umbilical cord – that contributes to the ambiguity of the scene – the naked man with his starched collar in the carefully structured interior, whose only outlet is the mirror. Bacon was fascinated by the human back (he describes how a Degas pastel shows a woman's spine almost coming 'out of the skin altogether') and this painting (left) allows for a dual exploration of his interest. The body of the figure with its flowing curves and rounded muscles and joints is centred within a geometric structure composed of straight lines. The yellow ring draws our attention off centre and contributes to the image's tense quality.

it into my hand and throw it on…. I can only hope that the throwing of the paint on to the already-made image or half-made image will either re-form the image or that I will be able to manipulate this paint further into – anyway, for me – a greater intensity.'

Controlling the accidental

Bacon's technique depended on encouraging an accidental element, skilfully and knowingly setting it up. For this purpose he gathered together the most varied tools and the most non-specific materials: brushes of all sorts, including a hand-held sweeping brush, aerosols, Letraset self-adhesive letters, rags, sponges, bits of velvet, a dustbin lid to make a circle, sand and dust, apparently

even his own cheek, deliberately unshaven in order to obtain a unique paint effect. It was while economizing by painting on the back of used canvases that Bacon discovered the technique of applying his materials to the reverse, unprimed side of the canvas – which has a more irregular, grainy surface, particularly when scraped and deliberately roughened – and then mounting it the wrong way round.

Bacon worked long hours developing his techniques, daily renewing his challenge to his materials – sometimes failing and abandoning or destroying his paintings. 'Half my painting activity', he said to Sylvester, 'is disrupting what I can do with ease.' His way of working was instinctual rather than considered, and it was the physical action of applying the paint that served as both his starting and his finishing point, and as a springboard from which to re-launch his painting. This is not to say that his technique lacks skill or to deny the contradictions in his work – between brushwork bordering on elegance, flat, thinly painted areas and uncontrollable jets of colour. At certain times in his career Bacon wanted his paintings put behind glass so that the viewer, rather than being held up by these breaks in style, would retain a global vision and be unable to escape the

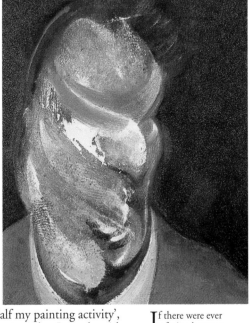

If there were ever a fusion between brushwork and figure, movement and expression, face and emanation, it is in this *Study for Head of Lucian Freud* (1967; above), with its overflowing folds of unstructured flesh, its bonelessness, composing a face and simultaneously concealing it, closing it off. Anything could be reversed in Bacon's book, including the canvas – which led to the principle of using the back as the front. Left: his signature on the reverse side of a panel from a small diptych of 1977.

distancing effect accentuated – perhaps to excess – by the reflective nature of the glass.

The painting and reality

In Bacon, therefore, we see a painter without formal training enjoying a freedom based on well-informed judgment and choice. He himself said: 'I want a very ordered image but I want it to come about by chance.' It was a contradiction, a technical challenge, that provided the mainspring for his work and underlay his attempts to convey the immediacy of a living being, of movement and reality. Curious about empirical reality and anxious to reach the truth, Shakespearian in his sense of solemnity and as fanciful as Lewis Carroll, Bacon takes up a struggle that is as old as art itself – with life and its accomplices, with flesh and pain, death and tragedy. And yet this man who was 'optimistic and totally without hope' also claimed to Sylvester he had 'always wanted and never succeeded in painting the smile'. Since 1944 his paintings have caused feelings of dismay and disgust, but they have also fascinated observers, stirring them out of any sense of complacency. If there is a human element in them it is conveyed in an image of humanity that is disjointed and incomplete. Half monster, half human, Bacon's creatures are frozen not in a pose or an image, but in time itself – time as a continuous phenomenon, a dimension that is a more essential part of reality than mere appearance. The challenge for the artist, therefore, is not to make visible a detached moment of general time, a story, anecdote or piece of narrative, but to demonstrate time itself as a continuum.

Time and reality

It is the artist's job to manifest what the naked eye cannot see, that field of contradictory forces – of movements, the application of effort and the relaxation of effort – that is the basis of organic life. Bacon is endeavouring to demonstrate a principle rather than describe a state, moving beyond beauty and ugliness, the individual and the particular. The image he produces is not a snapshot (like the arrested moment of a photograph) but the simultaneous manifestation of

The mirror in *Lying Figure in a Mirror* (1971; opposite), the dominant feature of this interior space, is a strange structure, and the title should be understood literally, with emphasis on the word 'in'. As Gilles Deleuze says in *Francis Bacon: Logique de la sensation* (1981): 'The body passes into the mirror and takes up its station there, along with its shadow. And this is the fascinating thing: there is nothing behind the mirror, only inside it. The body seems to stretch itself out, to lengthen and flatten in the mirror.' The illogicality of the situation – a reflection existing without a source – enables us above all (despite a few recognizable anatomical details) to see this outstretched body as a self-embracing figure, a being essentially contorted to the point of shapelessness, to the point where the distinction between one or two bodies can no longer be made. The figure is certainly a monster, but tends towards an expression of lasciviousness rather than constraint or pain, towards fusion with self rather than confrontation, amorous or otherwise, with another.

successive states, a series of muscular impulses that provide the most essential expression of a living reality. The body is a stage on which are played out the diastolic and systolic movements of the heart, its dilations and

The frame of the mirror encloses this *Lying Figure* in a vaguely menacing space.

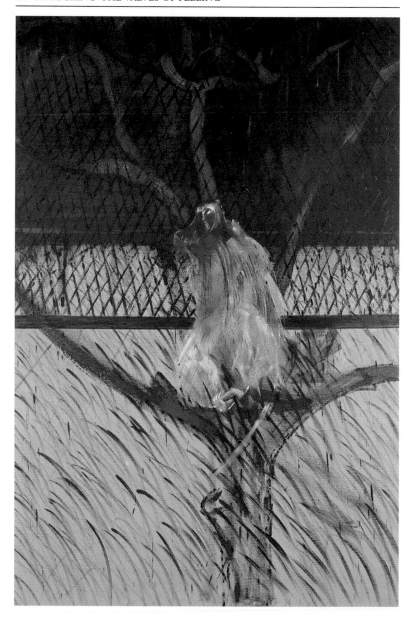

contractions. In painting this body becomes what Gilles Deleuze describes as the Figure: the capital letter emphasizes that the subject of Bacon's paintings is beyond the particular, beyond figuration, even when he paints named portraits, and even when those portraits are what is known as a good likeness. The Figure exists beyond identity, corresponding to a principle rather than a living being, a paradoxical principle that is expressed in the fragile state between appearance and disappearance, between equilibrium and disequilibrium within the painting space.

Monsters, animal and human

The earliest manifestations of the Figure were monsters, creatures that borrowed both from the human anatomy and from the visions of hell of a Hieronymus Bosch or the imaginary world of a Max Ernst. After the first triptych of 1944 came animal figures – such as *Dog* (1952), *Elephant Fording a River* (1952) and *Chimpanzee* (1955), all seen in mid-movement, in the state of flux that is the principle of organic life. At the same time Bacon began painting naked athletes, whose masculine beauty was a throwback to a rudimentary Michelangelo. The nude, painted in isolation, introduced its improbable postures, and the double nudes were intertwined in poses as combative as they were amorous. Then came the studies of male bodies, fully clothed, in banal

The monkey's mouth in *Study of a Baboon* (1953; opposite) resembles a human mouth, but the sheer animality of the figure strips it of any human psychology. It is centred against branches and a wire fence that echo the chequerboard in *Dog* (1952; left) and the grate of the drain in *Man with Dog* (1953; below), a work reminiscent of a painting by the Futurist Giacomo Balla. The monkey comes from a book on African fauna; the dog is based on

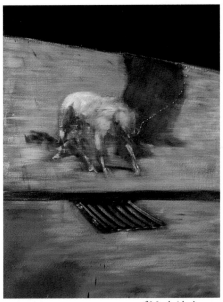

one of Muybridge's experiments; the man remains an enigma, half shadow, half ghost.

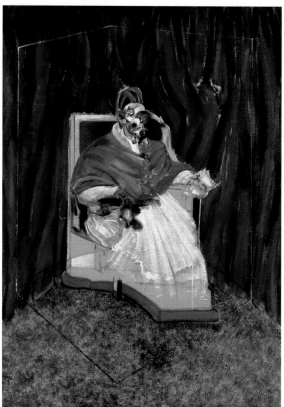

Fifteen years after the first paintings in the series (1950) Bacon returned to Velazquez's *Pope* with *Study from Portrait of Pope Innocent X* (1965; left), paying more attention to the 'decor' than in previous studies by placing the Pope in a particular setting – painting drapes behind his throne (pathetically held together with a safety pin) and giving the floor a distinctive treatment. This well-equipped Pope occupies the centre of the painting and is beginning to fuse with his attributes, his throne and the various objects in his hands. If the folds of his robes are simply but effectively suggested, his face, by contrast, is distorted and his body is absent beneath the papal robes. Despite his eagerness to return to the Velazquez painting, Bacon was to say to Sylvester in an interview of 1966: 'I've always thought that this was one of the greatest paintings in the world, and I've used it through obsession. And I've tried very, very unsuccessfully to do certain records of it – distorted records. I regret them, because I think they're very silly.'

situations, followed by a series of studies of the human head (rather than the face alone, since the head forms part of a whole). The *Heads* of 1948–9 were followed at the beginning of the 1950s by the heads of Popes; then, particularly from the 1960s onwards, came the portraits of friends – groups rather than series. If one of Bacon's first principles was to 'de-face' his figures, he also 'de-formed' their entire body, the space and world of his paintings: this device was a vehicle for his artistic vision.

Movement and distortion

If art was to succeed in capturing reality it had to be able to represent movement. Muybridge, the Italian

Futurists, Umberto Boccioni with his *Unique Forms of Continuity in Space* (1913) and Marcel Duchamp with his *Nude Descending a Staircase* (1912) had all signalled the way, and movement was already the stuff of cinema. One of the means of representing movement in art was to distort the image. Too bad, painters like Picasso and Bacon seem to be saying, if the price of this is to

The arrow (borrowed perhaps from Bacon's X-ray manual) gives greater energy to the figure in *Head II* (1949; below) and later works.

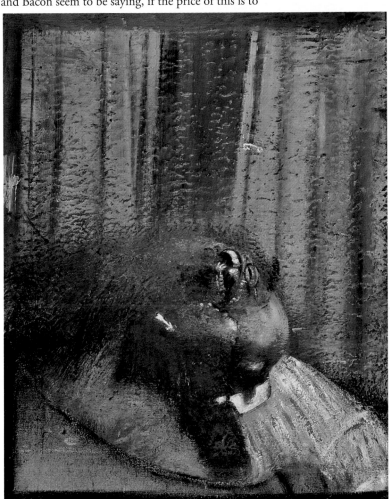

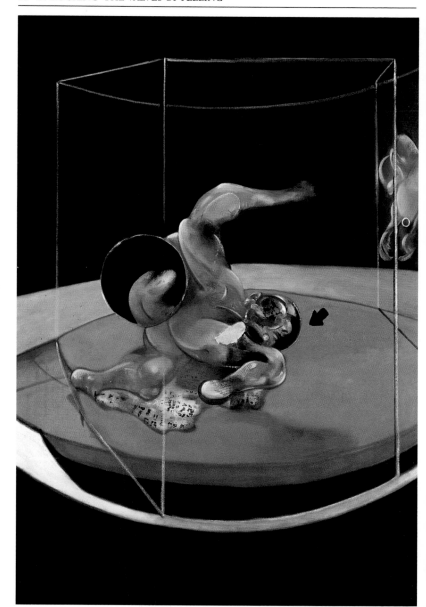

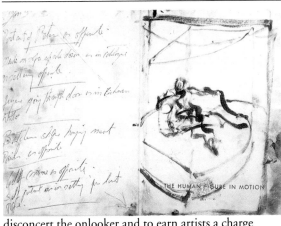

THE HUMAN FIGURE IN MOTION

Left: drawing on the title page of his copy of Muybridge's work, long thought to be one of the few Bacon ever did. Umberto Boccioni's bronze *Unique Forms of Continuity in Space* (1913; below) was a key work of modernism that opened the way for representations of movement in art alongside the latest experiments in photography. *Figure in Movement* (1976; opposite) is based on a key image: lovers embracing on a structure part bed, part cage. The figures intertwine and draw apart under the gaze of one of the Furies who seem to watch over human life from the 1944 triptych to Bacon's last works. The arrow and the magnified effects bring a clinical note to a scene that combines sensuality with a hieratic, monumental quality.

disconcert the onlooker and to earn artists a charge of cruelty when all they are guilty of is an enthusiasm for looking at the world. The violence is not in the distorting process, even if Bacon preferred to avoid painting in front of his models, knowing how hard it was for them not to feel victimized. As he said to Sylvester: 'I'm always hoping to deform people into appearance; I can't paint them literally.'

From spasm to spasm

Movement in Bacon's work means not only movement of the whole body or one of its parts, but also immobility and suspension, which are just another aspect of movement. It has its different modes: walking, cycling (*Portrait of George Dyer Riding a Bicycle*, 1966), making love (*Three Studies of Figures Lying on Beds*, triptych, 1972), but also falling; and it has its instruments and indicators (the discs and arrows, borrowed from technical imagery, give explicit indications). And with the thick white splotches sometimes placed on the image itself there is also movement *of* the paint

(rather than in it). When a body sits or stands or holds itself steady – these situations are the result of a host of tiny internal movements, which involve a degree of violence. These movements correspond to different movements in the paint, to sweeping or rubbed effects, and to the splitting and multiplication of the image, to a change of viewpoint, fragmentation and disjunction

until the human 'envelope' finally tears apart. The effect is of a world that is wounded, mutilated, torn in two. But this is precisely how it is with the body itself, the fragile, suffering body that is in a state of permanent flux, and that senses its existence more fully through suffering.

In *Portrait of George Dyer Riding a Bicycle* (1966; left) the figure is shown against a continuous, undifferentiated ground rare in Bacon's work: the painting, sanded like a circus ring (in fact Bacon mixed sand with the paint), provides an open arena where the cyclist performs his turns. The movement is playful and the figure of the clown cycling in different directions is comic. There is a hallucinatory quality in the indications regarding the figure's gaze, the movements of the machine, the blurring of the successive states of the body and the effect of suspension, but the thick layers of white paint obstructing the rotation of the wheels and the movement of the legs introduce a sense of reality. In the triptych *Three Studies of Figures on Beds* (1972; opposite) the background details create an impression of depth (in contrast with the portrait of Dyer), but the focus is firmly on the bed (stage) and the wrestling lovers. The sexual act, bordering here on pornography, is coldly played out within the circles. Bacon had difficulty defining love to Jean Clair: 'For me, it's an obsession with … something. A person, certain things. Painting speaks more clearly.'

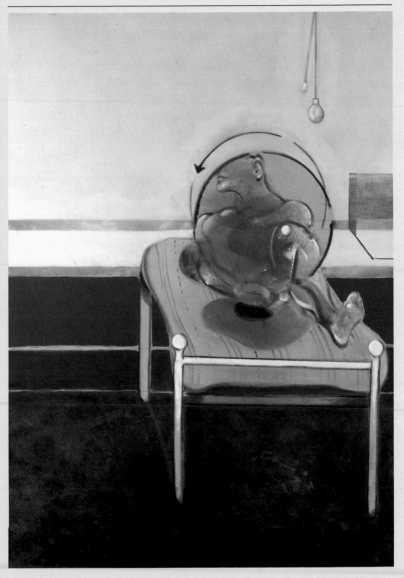

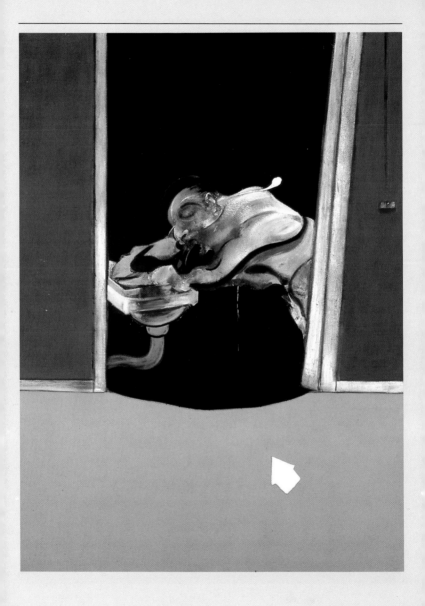

The flesh as sole possession

For Bacon the suffering flesh is inextricably linked with the experience of life itself and his own life in particular, as it is linked with the image of Christ on the cross and the concrete sensation elicited by a butcher's stall, by that same 'meat' that lives and breathes but that swiftly goes bad. The artist reminds us of this insistently, even with some satisfaction, through his depictions of skinned, bleeding, greenish flesh, and it is in this radical materialism, which goes far beyond repulsion or any other emotional affect, that his cruelty lies.

Meat, bodies and sex are intimately linked in his work. The body is made up of matter that is at once strange, banal and secret. Bacon undresses the Figure and places it, stripped of more than clothes, in intimate, even trivial situations: making love, in the bathroom, on the lavatory. And he details each moment, one by one: leg, buttocks, back, nape of the neck, feet (often), hands (very rarely); eyes whose expression is often concealed; head and mouth, the open mouth that so obsesses the artist, who claimed to Sylvester, rather provocatively: 'I've always hoped in a sense to be able to paint the mouth like Monet painted a sunset.' Our mouths, those public but also intimate apertures, are designed for speaking. But they also swallow, suck, blow, bite and suffer. They are a means of access to our interior space. They are fascinating like chasms in the ground, like all our holes, our orifices, our genitals, our anuses.

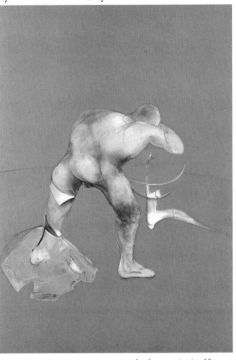

The violence of *Triptych, May–June 1973* (opposite), evoking Dyer's death, derives from the figure's posture of suffering and abandonment. The body empties itself – defecates, vomits – and prepares for another type of evacuation, assuming the shadow of the central panel can be read as death. The washbasin is a recurrent image (*Man at a Washbasin*, 1989–90; above) symbolizing disappearance into the vortex of our banal universe.

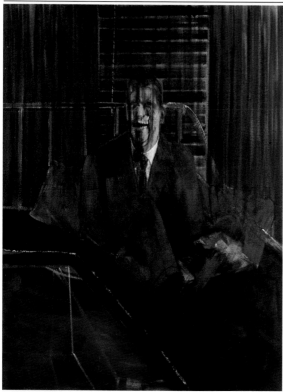

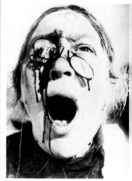

In an interview with Sylvester in 1966 Bacon explains the influence on him of Eisenstein's film *Battleship Potemkin*: 'It was a film I saw almost before I started to paint, and it deeply impressed me – I mean the whole film as well as the Odessa Steps sequence and this shot [of the nurse, above]. I did hope at one time to make – it hasn't got any special psychological significance – I did hope to make the best painting of the human cry. I was not able to do it and it's much better in the Eisenstein and there it is.' Bacon had already painted a series of open mouths developing this key image before it assumed such emblematic pictorial form as in *Study for a Portrait* (1953; above left).

Last scream

But our mouths scream, whereas Bacon's remain open in a silence without beginning or end. In Poussin's *Massacre of the Innocents*, which Bacon saw in Chantilly in 1929, and in the scene in Eisenstein's *Battleship Potemkin* (1925) where the nurse watches the pram tumbling down the steps, the screams are expressive, while Edvard Munch's *Scream* seems to fill the painting with an enormous wave of sound that we feel we can hear. There is a strange quality, on the other hand, to Bacon's screams – whether carnivorous laugh in *Study for a Portrait* (1953) or a drowning man's last plea for help in *Study after Velazquez's Portrait of Pope Innocent X* (1953). Bacon tells Sylvester, ambiguously, that he

'wanted to paint the scream more than the horror', at the risk, he adds, of making the screams 'too abstract': another way of saying that what he is trying to achieve has little to do with expression or psychology. He wants to believe, and to make us believe, that with painting one can maintain the distance and the non-dramatic quality of images in a medical handbook.

The question of expression still remains unresolved, however, with the named portraits and the self-portraits. These form an uninterrupted vein from the time that Lucian Freud (1951), Muriel Belcher, Isabel Rawsthorne and George Dyer contributed their names, at least, to works that can perhaps be said to be resemblances without expression, or at any rate without psychology. These are not so much states of mind as 'states of beings' – pierced, battered, but active beings. Spread across the panels of the triptych, solitude, distress and dereliction form a solid backcloth to these portraits, as elements of the common lot rather than signs of a particular resemblance.

The treacherous shadow

Resemblance is once again tested in the distance that exists between body and shadow, like the distance separating model and portrait. As sometimes happens in Max Ernst's work, these shadows enjoy an extraordinary freedom in relation to the bodies that cast them. Manifested as a simple patch of gaudy colour, or a pool of flesh, they often betray their origin by becoming something else – a dog in George Dyer's shadow in *Two*

Bacon's many 'small' triptychs (35.5 cm × 30.5 cm or 14 × 12 in.) form a series like the large ones. In *Three Studies for Portrait of Lucian Freud* (1965; below) the continuity established by the red ground links three images so mutilated that they might prove difficult to read if they were not seen as being complementary. The artist plays with his materials here, varying the consistency of the paint and his means of applying it (using rubbed effects and imprints). His engagement with the work consists in breaking up the image so as to re-create it more effectively in its specific pictorial context. But a photograph was sufficient for the purpose and Bacon was always careful to spare his models the torture of sitting for him in his studio, knowing full well the effect of such a loss of integrity.

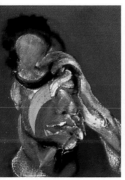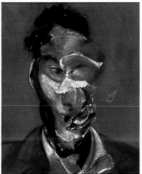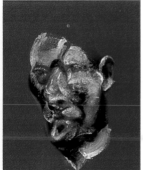

Studies of George Dyer with Dog (1968) or a diabolical figure in *Triptych, May–June 1973* – or by indicating the presence of another figure beyond the frame. Identity is never more than this uncertain coincidence that brings the individual face to face with his ghost – or vice-versa. We are a long way here from the principle of illustrative or descriptive representation: emerging from the action of painting, through a process of transformation and distortion, Bacon's distinctive Figure is a creature without story or references that we have seen in several of its guises – guises that are almost essentially corporeal, like anatomical elements, manifestations of a physical reality. It is a creature we have seen stripped of nerve and bone.

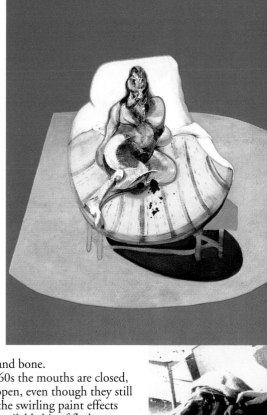

In the paintings of the 1960s the mouths are closed, but the eyes are sometimes open, even though they still appear to see nothing. And the swirling paint effects sweep into their path every available bit of flesh, noses, cheeks, shoulders, entire arms.... The Figure bears some resemblance to the Belvedere Apollo or one of Ingres' figures, divested of detail; it remains, with its capital F, the primary instrument of the painter's dream, that reality of sensation which is arguably the foundation of his art and the source of its wisdom.

In *Study for Portrait of Henrietta Moraes on a Red Ground* (1964; above) the bed, 'arena' and red ground isolate the figure and create a feeling of weightlessness.

Sensation captured in paint

The dream (or daydream) of painting sensation is not exclusive to Bacon and underpins the work of numerous

modern artists. Empiricism, that particularly British phenomenon, also has a part to play here, for sensation, surely, is a link with the reality that is both in things and in the self? Artists are engaged not only in experiencing sensations, like anyone else, but in evaluating them, in knowing and recognizing them, and refining them so as to give them new form. Cézanne and Bacon (but also in their way artists like Henri Matisse and Paul Klee) share an idea of the continuity between the object viewed and the sensation this produces in the viewer, a continuity that is almost

In *Study of a Man and a Woman Walking* (1988; below) the sexes are united as body and shadow, not without signs of conflict.

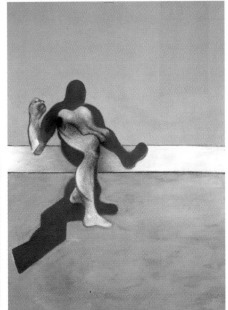

physical. The artist's job is to record this sensation. In Bacon's case the sensation passes directly to the nervous system, without the intermediary of the brain or intellect, less still of knowledge and speech. The choice of a painting style that depends on suggestion and accident reduces the distance between the 'flesh' of things and the flesh of the observer. As he told Sylvester in an interview in 1962, it is 'more poignant than illustration. I suppose because it has a life completely of its own. It lives on its

While Bacon mainly concentrates on painting the face or head of Isabel Rawsthorne, the multiple versions derived from John Deakin's photograph (left) explored Henrietta Moraes' body, representing it in terms of whorls all converging or intersecting in the area of her lower stomach – which remains blurred or shadowy, or concealed by patches of paint.

own, like the image one's trying to trap; it lives on its own, and therefore transfers the essence of the image more poignantly. So that the artist may be able to open up or rather, should I say, unlock the valves of feeling and therefore return the onlooker to life more violently.' These words – 'unlock[ing] the valves of feeling' – tell us so much about what Bacon is trying to achieve that they could be used to sum up his artistic procedure.

Bacon was constantly discovering new ways to paint his models

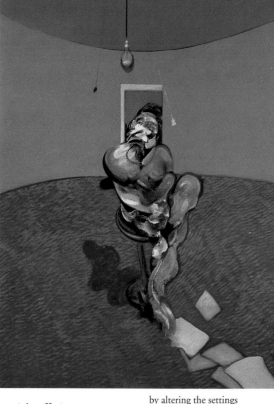

Order and chaos

Listening to Bacon, it is easy to understand how little this sensation has to do with the sensational, with facile effects, or with feelings of repulsion or passions of any kind. The spectacle of pain and the violence that emerges out of the artist's work refer us back to naked matter, to chaos as the common condition of life. But the paintings are an attempt to introduce order and not disorder into the banality of our existential suffering.

by altering the settings and variously distorting the image, as in *Portrait of George Dyer Talking* (1966; above), where his intimacy with his model gave the artist a peculiar insight into Dyer's physical make-up – the energy and power he was barely able to contain.

The artist hovers between gloomy humanism, creative empiricism and hedonistic frenzy, converting pain, that hallmark of existence, into the will to organize things despite the provisional nature of his life.

It is an ambition more readily recognized in writers, including those very writers who figure in the artist's conversation and in the titles of some of his paintings: Baudelaire, Racine, Shakespeare (Bacon liked to joke about the fact that Shakespeare's works were attributed

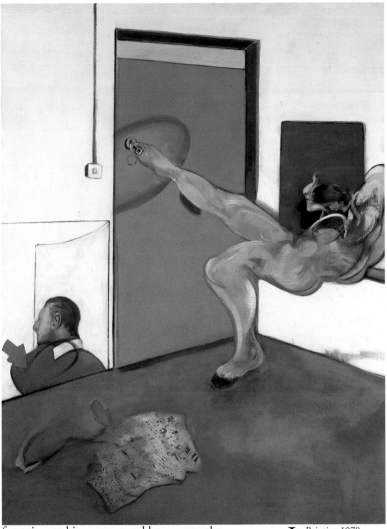

for a time to his ancestor and homonym, the philosopher Francis Bacon, among many others) and more recent Anglo-Saxon writers – Yeats, Pound and Eliot. Asked by Sylvester whether he intended to create a tragic art, Bacon replied: 'No. Of course, I think that, if

In *Painting 1978* (above) the geometry of the constructed space is undermined to create 'a deeply organized chaos'.

one could find a valid myth today where there was the distance between grandeur and its fall of the tragedies of Aeschylus and Shakespeare, it would be tremendously helpful.'

Existence as sole belief system

There is no place, however, for an Orestes or a Macbeth in our century and myths can no longer bear the full weight of tragedy, as Bacon explained to Sylvester: 'But when you're outside a tradition, as every artist is today, one can only want to record one's own feelings about certain situations as closely to one's own nervous system as one possibly can.' The artist is reduced simply to being himself, with existence as his only belief system, forced to try and make something of it. Bacon became an increasingly isolated figure over the years, cut off from society and living, despite his modernity, in the manner of a 19th-century romantic, experiencing the world in isolation, reinterpreting in his own fashion Descartes' *cogito ergo sum* as *doleo ergo sum*: 'I suffer, therefore I am.'

Tragedy from day to day

While classical tragedy undoubtedly provides a model, the drama of our times is no longer played out in the theatre, even in the plays of Beckett, who has been linked with Bacon because of his Irish origins and his determination to 'touch the bottom'. Drama might more appropriately be called violence, a violence that is deeply ambiguous in the case of Bacon: always in hiding, it seems, if only behind a front of ordinariness, in the 'banality of evil' referred to by Hannah Arendt that she sees embedded in the history of our century and the horrific events of the Holocaust. Bacon for his part always refused to explain any potential connection between his art and his time, as if he preferred to confine himself to the form of egoism that is arguably one of the conditions of the artist. He refers the violence back to himself, simultaneously claiming responsibility for it and denying the violence altogether. As he said in *Francis Bacon: In Conversation with Michel Archimbaud* (1993): 'I'm always very surprised when people speak of violence in my work. I don't find it at all violent

'I think that only time tells about painting. No artist knows in his own lifetime whether what he does will be the slightest good, because I think it takes at least seventy-five to a hundred years before the thing begins to sort itself out from the theories that have been formed about it. And I think that most people enter a painting by the theory that has been formed about it and not by what it is. Fashion suggests that you should be moved by certain things and should not by others. This is the reason that even successful artists – and especially successful artists, you may say – have no idea whatever whether their work's any good or not, and will never know.'

Francis Bacon in
David Sylvester
*Interviews with
Francis Bacon*, 1993

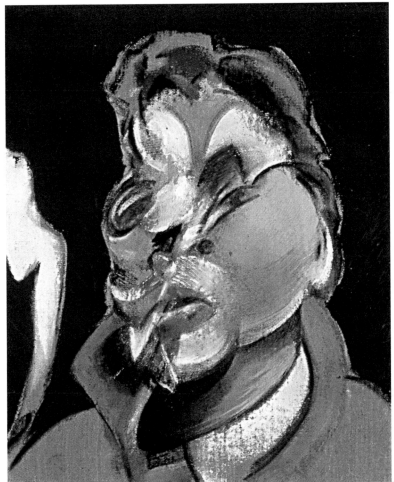

myself.... There is an element of realism in my pictures, which might perhaps give that impression, but life is so violent; so much more violent than anything I can do!' In the same conversation, referring to Picasso, he added that there is a necessary violence in painting: 'Violence which opens the door to something else. It is rare, but that's what can ... be produced by art; images can shatter the old order leaving nothing the same as before.'

The face of this *Self-Portrait* (1969; above), part of a triptych painted using a method-ically random process and drowning in its own features, is typical of Bacon's numerous small self-portraits.

Bacon died in 1992 in Madrid, where he had gone in anticipation of a forthcoming show, but more importantly to visit a close friend. He had never stopped working; his paintings were still selling well and several major exhibitions were in preparation.

In his studio a picture (no doubt one of several) stood on the easel: the bulk of the canvas was bare, while in the centre a painted face was caught up in a web of lines as if suspended in mid-struggle. In Andrew Sinclair *Francis Bacon: His Life and Violent Times* (1993), Bacon speaks about his own method of working: 'I know that in my own work the best things are the things that just happened – images that were suddenly caught and that I hadn't anticipated. We don't know what the unconscious is, but every so often something wells up in us. It sounds pompous nowadays to talk about the unconscious, so maybe it's better to say "chance". I believe in a deeply ordered chaos and in the rules of chance. I have to hope that my instincts will do the right thing because I can't erase what I have done.'

The journey that began with the monsters of the 1940s came to an end for the artist fifty years later, but for us the journey continues: for if the flesh dies, sensation lives on.

The title of two large triptychs owe little to Bacon (who preferred that they should be 'read' without recourse to words). In the violent vision of existence offered by *Triptych Inspired by T. S. Eliot's Poem 'Sweeney Agonistes'* (1967; opposite) the individual is menaced by the physical presence and even by the gaze of another person. The central panel shows a bundle of horrific remains: a conflation of a news item with an echo from Eliot and Bacon's own determination to remove all human presence from the scene – absence being the worst violence of all. The mysterious creature in *Triptych Inspired by the Oresteia of Aeschylus* (1981; overleaf) seems to have escaped the organic world as we know it and hovers midway between primitive being and futurist android. The flesh exists, suffers; blood spills and night threatens from the other side of the door.

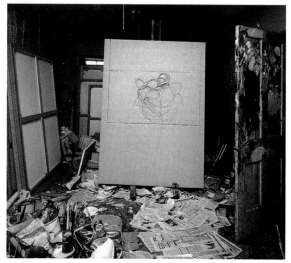

Left: the early stages of a work in progress, left in the studio at the time of Bacon's death in 1992. Bacon still had paintings to paint and imagined himself living one hundred and fifty years or more.

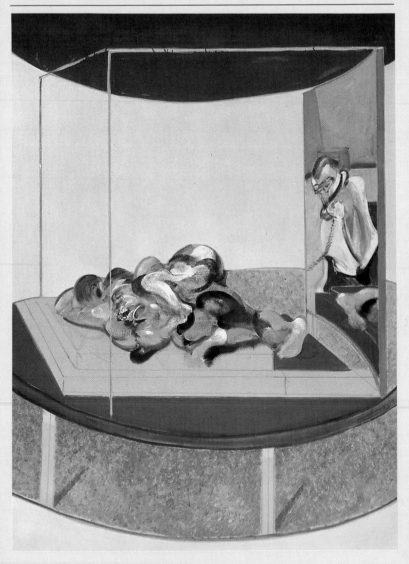

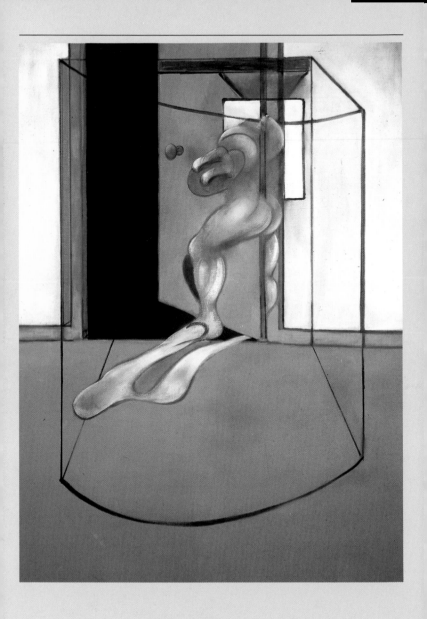

DOCUMENTS

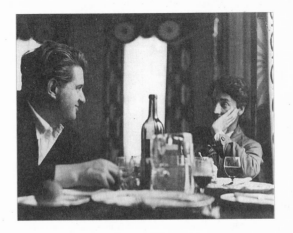

'If you can talk about it, why paint it?'
Francis Bacon in Andrew Sinclair, *Francis Bacon*, 1993

Isolated scenes

The photographer and writer Daniel Farson was an active member of Soho's gay art scene in the 1950s and 1960s whose anecdotal biography of Bacon fleshes out the personal dimension of the artist's life. The stories he records reveal the different aspects of Bacon's complex personality, showing him often in an attractive light but also as a hard person, not without his weaknesses.

Addicted to Soho

At Muriel's as at Wheeler's, Francis always signed the bill, or the round was simply added to the 'tab', and I assume that by the time of my arrival the days of his weekly ten-pound touting fee were over. Instead, Muriel seemed to allow him limitless credit. He waved his bottle of champagne, slopping it into the glasses of those around him, spilling much of it on the floor, with the Edwardian toast: 'Real pain for your sham friends, champagne for your real friends!', a habit he had acquired from his father. He would add his inimitable 'Cheerio!' with a radiant smile and a tug at his collar, an image that shines brightly in my mind today....

When I first came to Soho he looked at least ten years younger than his age – thirty rather than forty-three. This was partly achieved by the carefully dishevelled hair of variable colour, and by his customary black leather jacket bought in the South of France. Such an outfit might not have worked with other men, but the masculinity of the jacket, and I think it preceded Brando's, enhanced his features so naturally that it was hard to imagine him wearing anything else.

But even on this, his home ground in the Colony, Francis was never wholly relaxed, observing people in the mirror as if he too had eyes in the back of his head. It was some time before I realized that, when he wandered off to the lavatory with his glass in his hand as if he could not bear to part with it, he threw the contents away; he drank less while filling the glasses of those around him so they disintegrated sooner....

B acon in London, c. 1977–8.

Bacon at work

John Richardson, the author of the definitive life of Picasso, described how Francis used to let his stubble grow for three or four days and then rehearse the brushstrokes on his face in front of the mirror: '… those strange revolving brushstrokes, that are so familiar from his pictures, would be rehearsed with Max Factor pancake make-up. He had a series of these Max Factor pots and he would take one and do a sort of smear across his face, and these are the smears that you see on so many of the faces of many of those early paintings.' Richardson even compared the reverse 'woolly' side of the canvas to the stubble on Francis' face!

'Drawing' directly on to the canvas, then, with a brush but no preliminary sketch, he began with the central image, his furious brushstrokes contrasting with the careful background area. As Andrew Durham explained in a Tate Gallery booklet, the sedate background was adapted as the image progressed: 'He may not always work fast and furiously, but the paintings he regards as the more successful are in general the ones he paints quickly.' The brushstrokes varied 'from calligraphic arabesques, through sharp stabbing strokes to the almost watercolourist's delicacy of the treatment of the hair in the right-hand figure of *Triptych 1972*, to voluptuous impasto with a heavily laden brush, and the dragging of dry paint across the surface to leave encrustations rather than brushstrokes. Elsewhere he picks the brush off the surface to leave sharp peaks and serrated ridges of paint'.

Francis told me once that he never had the studio in Reece Mews cleaned because it helped him to lift up dust from the floor and apply it to the canvas when painting his sand dunes; he also rubbed his fingers along the dust and then on to the wet paint. He used traditional artist's oils without the addition of varnish, and squeezed them directly in thick dollops from the tube on to the canvas – in Andrew Durham's words 'high impasto and dry scumbles where the medium seems to have been soaked out, to very thin washes where a good deal of turpentine has been added to modify the tube paints. He seems to delight in the subtlety and malleability of this medium'.

Like many artists, Francis used his fingers and small sponges to smear effects, and even a piece of corduroy to impose a cross-hatching impression by pressing it against a face on the canvas. Though he obeyed no rules, he took advantage of practical methods to create his straight lines, and Letraset for his lettering – the closest he came to collage, though he used it haphazardly to enhance the central image. I once mentioned that I had seen Michael Andrews' studies of Ayers Rock and was not entirely happy with his obvious use of acrylic and spray gun. Francis looked at me knowingly and chose his words carefully, as he replied slowly: 'As a matter of fact I use a spray gun and acrylic myself.'

'You do?' I exclaimed.

'Yes,' he smiled, 'but I use them less obviously!'

He explained that acrylic was quick-drying and useful, especially for the large expanse of flat colour in the background, unless he exploited the bare texture of the canvas itself. Against this, Francis would use the canvas like a dartboard, flicking paint to let it drip….

The act of destruction

Francis had such exacting standards that he was impatient with paintings which just failed to satisfy, turning against them impetuously as if they were strangers who displeased. Consequently the Sainsburys [Lisa and Robert] were dismayed when his friend Paul Danquah warned them that the best of the eight portraits had been destroyed, and dreaded the early phone call: 'There's no need to come for the sitting today – it's *gone*.' They were so anxious when he referred enthusiastically at a party to a new painting of a Pope as 'a wonderful picture' that they offered him a lift home in the hope of seeing it and possibly buying it. On the way he decided it was no good after all; by the time they arrived, he declared that it had to be destroyed.

'You can't,' they pleaded.

'You'd better come in and see if you like it,' he relented. But once inside he took a razor blade and slashed it. 'He gave us what was left of the canvas,' they said, 'which we rolled up and put on the roof of our car before he could change his mind. The next morning we went to Alfred Hecht, who trimmed and framed it.'…

One of the hardest lessons for an artist is to know when to leave well alone. Usually Francis drew back in time, but when he realized he had gone too far he was ruthless. *The Times* claimed he destroyed seven hundred paintings in this early period, and if only half that number was correct there is reason to fear it included many paintings which should have been saved.…

A harsh critic

If Francis was impeccable at his own private views, he could be vicious at those of others. I feel a twinge of shame as I remember how ungenerously we behaved at the private views in Cork Street. Francis knew that you are vulnerable when you praise but cannot go wrong if you criticize, for who can deny you? It was one of his few weaknesses that he was grudging in his support for other artists. We emerged from galleries spluttering with ill-concealed mirth. 'Well!' Francis exclaimed on one occasion as he leaned against a lamp-post because he was laughing so uncontrollably. 'I really *am* better, aren't I!'

The danger was that with his exact emphasis everyone found his commentary hilarious. Again signs his victims ignored the warning as they dared enlist his attention or curry favour. Lady Caroline Blackwood remembers one instance: 'Francis was being pestered by an irritating artist to come to his studio to look at his paintings, and the man concluded that Bacon refused because they threatened him. Francis replied that he did not feel in the least threatened: "I don't want to come to your studio," he explained with devastating accuracy, "because I've seen your *tie*!"'…

Francis frequently left behind canvases which were sold by those who came after him. In the sixties, the playwright Frank Norman witnessed a scene in Bond Street when Francis passed a gallery and spotted a picture of his which he had discarded in Tangier. Going inside, he asked how much it cost and was told £50,000. Writing out a cheque without a moment's pause, he carried the picture outside where he stamped it to death on the pavement.…

If Princess Margaret has a memory of Francis Bacon it is unlikely to be happy;

his presence at a party could be a time bomb, and in this case it went off. The posher the occasion, the more outrageously he could behave.

Lady Caroline Blackwood, who married Lucian Freud, remembers the ball given by Lady Rothermere. Champagne flowed so abundantly that the Princess was 'seized by a desire to show off'. She grabbed the microphone from the startled singer of the band, whom she instructed to play songs by Cole Porter....

Princess Margaret knew the songs by heart but she sang them hopelessly off-key, egged on by her sycophantic audience of ladies laden with jewellery and gentlemen penguins in white ties and tails....

She was starting on the familiar lyrics of 'Let's Do It' when 'a very menacing and unexpected sound came from the back of the crowded ballroom. It grew louder and louder until it eclipsed Princess Margaret's singing. It was the sound of jeering and hissing, of prolonged and thunderous booing. Princess Margaret faltered in mid-lyric. Mortification turned her face scarlet and then it went ashen. Because she looked close to tears, her smallness of stature suddenly made her look rather pitiful'. The Princess abandoned the microphone and was hurried out of the ballroom by her flustered ladies-in-waiting as the band stopped playing, uncertain what to do, and Lady Rothermere's guests asked each other what had happened....

Afterwards Francis said: 'Her singing was really too awful. Someone had to stop her. If you're going to do something, you shouldn't do it as badly as that.'...

A few, a very few, were able to stand up to Francis. Fred Ingrams was delighted when Francis left the Colony to see a mixed exhibition at the new Birch and Conran Gallery next door, where he bought one of Fred's pictures 'because it's the only good thing there'. 'I felt eighteen feet off the ground,' says Fred. Francis had given the gallery an encouraging send-off, though James Birch feared Francis was so drunk that it was unlikely he would remember it the next morning. However, he came in as promised and wrote out his cheque for £450. Several months later I was talking to Fred in the French when Francis sidled in. As he failed to recognize Fred, I introduced them, adding provocatively: 'You remember, Francis – you bought one of Fred's paintings.'

'Really!' Francis shook himself indignantly like a dog coming out of the water. 'I suppose I was pissed. I wonder what's happened to it.' Fred may have been hurt, but he had the wit to list Francis Bacon as one of his 'collectors' in the catalogues to his recent one-man shows. Today he is established as one of our most promising young artists....

On another occasion that was memorable for me, we continued from the Colony to the French and then the Golden Lion, where Francis was in such lively form that someone asked him what he did.

'I'm a painter.'

'That's lucky,' said the man. 'I'm doing up my house at the moment and can give you some work if you want it.'

'How very kind of you,' said Francis with his broadening smile.

Only a few days earlier one of his pictures had sold in New York for £3 million.

Daniel Farson
The Gilded Gutter Life of Francis Bacon
1993

'Provoking accidents, prompting chance'

Bacon's love of conversation and enthusiasm for argument, his emphatic manner of speaking and acuity of vision were also evident in his day-to-day dealings and in his interviews with critics and friends. Published in Art International *in 1989, his conversation with the critic Michael Peppiatt (MP) was one of the last statements made by Bacon (FB) regarding his art.*

MP You told me recently that you'd been to the Science Museum and you'd been looking at scientific images.

FB Yes, but that's nothing of any interest. You see, one has ideas, but it's only what you make of them. Theories are no good, it's only what you actually make. I had thought of doing a group of portraits, and I went there thinking that, amongst various things, I might find something that would provide a grid on which these portraits could be put, but I didn't find what I wanted and I don't think it's going to come off at all.

MP Are there certain images that you go back to a great deal, for example Egyptian images? You look at the same things a lot, don't you?

FB I look at the same things, I do think that Egyptian art is the greatest thing that has happened so far. But I get a great deal from poems, from the Greek tragedies, and those I find tremendously suggestive of all kinds of things.

MP Do you find the word more suggestive than the actual image?

FB Not necessarily, but very often it is.

MP Do the Greek tragedies suggest new images when you reread them, or do they just deepen the images that are already there?

FB They very often suggest new images. I don't think one can come down to anything specific, one doesn't really know. I mean, you could glance at an advertisement or something and it could suggest just as much as reading Aeschylus. Anything can suggest things to you.

MP For you, it's normally an image that is suggested though, it's not a

Bacon at the Grand Palais retrospective in Paris in 1971.

sound, it's not words sparking off words. Words spark off images.

FB To a great extent. Great poets are remarkable in themselves and don't necessarily spark off images, what they write is just very exciting in itself.

MP You must be quite singular among contemporary artists to be moved in that way by literature. Looking at, for example, Degas, doesn't affect you?

FB No. Degas is complete in himself. I like his pastels enormously, particularly the nudes. They are formally remarkable, but they are very complete in themselves, so they don't suggest as much.

MP Not so much as something less complete? Are there less complete things which do? For example, I know you admire some of Michelangelo's unfinished things. And recently you were talking about some engineering drawings by Brunel and it sounded as though you were very excited by them.

FB In a certain mood, certain things start off a whole series of images and ideas which keep changing all the time.

MP Is there a whole series of images that you find haunting? There are specific images, aren't there, that have been very important to you?

FB Yes, but I don't think those are the things that I've been able to get anything from. You see, the best images just come about.

MP So that's almost a different category of experience.

FB Yes. I think my paintings just come about. I couldn't say where any of the elements come from.

MP Did you ever experiment with automatism?

FB No. I don't really believe in that. What I do believe is that chance and accident are the most fertile things at any artist's disposal at the present time.

I'm trying to do some portraits now and I'm just hoping that they'll come about by chance. I want to capture an appearance without it being an illustrated appearance.

MP So it's something that you couldn't have planned consciously?

FB No. I wouldn't know it's what I wanted but it's what for me at the time makes a reality. Reality, that is, that comes about in the actual way the painting has been put down, which is a reality, but I'm also trying to make that reality into the appearance of the person I'm painting.

MP It's a locking together of two things?

FB It's a locking together of a great number of things, and it will only come about by chance. It's prompted chance because you have in the back of your mind the image of the person whose portrait you are trying to paint. You see, this is the point at which you absolutely cannot talk about painting. It's in the making.

MP You're trying to bring two unlike elements together.

FB It has nothing to do with the Surrealist idea, because that is bringing two things together which are already made. This thing isn't made. It's got to be made.

MP But I mean that there is the person's appearance, and then there are all sorts of sensations about that particular person.

FB I don't know how much it's a question of sensation about the other person. It's the sensations within yourself. It's to do with the shock of two completely unillustrational things which come together and make an appearance. But again it's all words, it's all an approximation. I feel talking about painting is always superficial. We

have lost our real directness. We talk in such a dreary, bourgeois kind of way. Nothing is ever directly said.

MP But are there things that really jolt you? I know you love Greek tragedy, Shakespeare, Yeats, Eliot and so on, but do odd things, like newspaper photographs, jolt you every now and then?

FB I don't think photographs do it so much, just very occasionally.

MP You used to look at photographs a lot. Do you still look at books of photographs?

FB No. Dalí and Buñuel did something interesting with the *Chien Andalou*, but that is where film is interesting and it doesn't work with single photographs in the same way. The slicing of the eyeball is interesting because it's in movement....

MP But is your sensibility still 'joltable'? Does one become hardened to visual shock?

FB I don't think so, but not much that is produced now jolts one. Everything that is made now is made for public consumption and it makes it all so anodyne. It's rather like this ghastly government we have in this country. The whole thing's a kind of anodyne way of making money.

MP I suppose one doesn't have to be jolted as such to be interested, to be moved. One can be persuaded or convinced by something without it actually shocking one's sensibility. And I am sure that people have come to accept images that begin by seeming extremely violent, war pictures for instance.

FB They are violent, and yet it's not enough. Something much more horrendous is the last line in Yeats' 'The Second Coming', which is a prophetic poem: 'And what rough beast, its hour come round at last,/Slouches towards Bethlehem to be born?' That's stronger than any war painting. It's more extraordinary than even one of the horrors of war pictures, because that's just a literal horror, whereas the Yeats is a horror which has a whole vibration, in its prophetic quality.

MP It's shocking too because it's been put into a memorable form.

FB Well, of course that's the reason. Things are not shocking if they haven't been put into a memorable form. Otherwise, it's just blood spattered against a wall. In the end, if you see that two or three times, it's no longer shocking. It must be a form that has more than the implication of blood splashed against a wall. It's when it has much wider implications. It's something which reverberates within your psyche, it disturbs the whole life cycle within a person. It affects the atmosphere in which you live. Most of what is called art, your eye just flows over. It may be charming or nice, but it doesn't change you.

MP Do you think about painting all the time, or do you just think about things?

FB I think about things really, about images.

MP Do images keep dropping into your mind?

FB Images do drop in, constantly, but to crystallize all these phantoms that drop into your mind is another thing. A phantom and an image are two totally different things.

MP Do you dream, or remember your dreams? Do they affect you at all?

FB No. I'm sure I do dream but I've never remembered my dreams. About two or three years ago I had a very vivid dream and I tried to write it down because I thought I could use it. But it was a load of nonsense. When I looked

at what I'd written down the next day, it had no shape to it, it was just nothing. I've never used dreams in my work. Anything that comes about does so by accident in the actual working of the painting. Suddenly something appears that I can grasp.

MP Do you often start blind?

FB No, I don't start blind. I have an idea of what I would like to do, but, as I start working, that completely evaporates. If it goes at all well, something will start to crystallize.

MP Do you make a sketch of some sort on the canvas, a basic structure?

FB Sometimes, a little bit. It never, never stays that way. It's just to get me into the act of doing it. Often, you just put on paint almost without knowing what you're doing. You've got to get some material on the canvas to begin with. Then it may or may not begin to work. It doesn't often happen within the first day or two. I just go on putting paint on, or wiping it out. Sometimes the shadows left from this lead to another image. But, still, I don't think those free marks that Henri Michaux used to make really work. They're too arbitrary.

MP Are they not conscious enough, not willed enough?

FB Something is only willed when the unconscious thing has begun to arise on which your will can be imposed.

MP You've got to have the feedback from the paint. It's a dialogue in a strange sense.

FB It is a dialogue, yes.

MP The paint is doing as much as you are. It's suggesting things to you. It's a constant exchange.

FB It is. And one's always hoping that the paint will do more for you. It's like painting a wall. The very first brushstroke gives a sudden shock of reality, which is cancelled out when you paint the whole wall.

MP And you find that when you start painting. That must be very depressing.

FB Very.

MP Do you still destroy a lot?

FB Yes. Practice doesn't really help. It should make you slightly more wily about realizing that something could come out of what you've done. But if that happens....

MP You become like an artisan?

FB Well, you always are an artisan. Once you become what is called an artist, there is nothing more awful, like those awful people who produce those awful images, and you know more or less what they're going to be like.

MP But it doesn't become any easier to paint?

FB No. In a way, it becomes more difficult. You're more conscious of the fact that nine-tenths of everything is inessential. What is called 'reality' becomes so much more acute. The few things that matter become so much more concentrated and can be summed up with so much less.

'Provoking Accidents, Prompting Chance; An Interview with Francis Bacon', *Art International*, no. 8, autumn 1989

Greek tragedy as a backcloth

Bacon drew on both visual and literary sources, ranging widely in his choice of references. His work is imbued with the atmosphere of classical drama, mirroring the symbolism and the figures and settings of Greek tragedy.

B acon reading a Greek grammar book.

How the Erinyes became the Eumenides

Aeschylus (c. 525–456 BC) was the first of the great trio of Athenian tragedians who included Sophocles and Euripides and it is in his trilogy (triptych?) devoted to the terrible story of Orestes that the Erinyes, spirits of vengeance from the underworld, make their appearance. Inspired by Apollo, Orestes, son of Agamemnon and Clytemnestra and brother of Electra, avenges his father's murder by killing his mother and her lover Aegisthus. The Erinyes appear before him in the exodus (final scene) of the play The Choephori, *their mission henceforth to pursue and punish the matricide.*

Orestes: My dirge is for all the deeds done by this bloodclan.

I've won this bout but the laurels are blood-smirched....
Ah! Look! Coming! Gorgons. Garb black, entwined with snakes for hair. I've got to run....
These aren't in the mind. They're real and they're near.
My mother's grudge-dogs close at my heels....
You can't see them. I can though.
They're baying for my blood. I've got to go.

The prologue of The Eumenides *shows the Erinyes more determined than ever. To protect Orestes, who has taken refuge in the sanctuary at Delphi, Apollo sends the spirits to sleep. It is the priestess who first encounters them.*

Priestess: In front of this person, a strange group of she-hags
sighing and snorting, asleep on the thronestools.

Not women really, but more like the
 Gorgons.
I call them Gorgons but they weren't
 that exactly.
I once saw a picture of Harpiae,
 Graspers,
unflaggingly swooping on Phineus the
 Thracian....
These were black like Harpiae but they
 were wingless.
The snorts from their nostrils would
 keep you a mile off.
Their eye-sockets glued with sickening
 ooze-clots.
Their grave-garb's all wrong for the
 statues of godheads
nor would it seem right in the houses of
 mortals.
Don't know what brute-clan this brood
 belongs to,
what region would want to boast that it
 bred them
and didn't wish now that their birth had
 aborted....

*According to the stage directions, the
Erinyes would have been wheeled on to the
stage on a special platform mounted on
castors – which has its equivalent in the
pedestal-cum-platform that features so
prominently in Bacon's work. While
Orestes flees to the Acropolis at Athens to
be tried for his crime, Apollo appears and
drives out the Erinyes, addressing them in
the following terms.*

Apollo: You belong where heads go
 splat off the hackblock,
eyes get gouged out and lugged from
 their sockets,
where bloodright's castrations, boys'
 ballocks battered,
men spitted on stakespikes screaming for
 mercy.
Your bat-snouts go snorting in society's
 bloodtroughs.

It's the food you get fat on makes you
 hated by he-gods.
All your appearance says blood food and
 filth baths.
You hags should live in the beast dens in
 jungles,
dark lairs all larded with shit and chewed
 gristle,
not here, contagious to all you come
 close to.
Get out! Out you go! You goats with no
 goatherd!

*The Erinyes sing their response. This is
their first* stasimon, *or song sung by the
chorus.*

Chorus: That's how it is, and that's how
 it's staying.
We've got all the skills. We get things
 accomplished.
We memorize murders. We're never
 forgetful.

We terrify mortals. We spit on their
 pleadings.
We relish our office, though spurned by
 the he-gods.

We're despised, we're rejected. The light
 we work by
is nothing like sunshine. Sharp and
 sheer-sided
our tracks are a peril to blind and to
 sighted.

*Finally, thanks to Athena's help, Orestes
obtains a favourable judgment. The
goddess persuades the Erinyes to adopt the
cause of virtue and change their name to
Eumenides, the Kindly Ones. Orestes is
saved. But the terrifying image of the
Erinyes has not been expunged, and the
menace lives on in Bacon's paintings.*

Aeschylus, *The Oresteia*,
translated by Tony Harrison, 1981

Poetry as a source of visual images

Bacon found an inexhaustible source of images in the verse of T. S. Eliot, the 'father' of modern poetry and one of the dominant poetic figures of the English-speaking world between the wars, and in that of the poet and dramatist W. B. Yeats, who also played an active role in Irish politics. Bacon admired Eliot's work for its 'total atmosphere of despair', while Yeats inspired in him at times a horror that has a 'genuine vibration', and the poetry of both resonated for him in such a way as to leave a profound mark on his artistic universe.

T. S. Eliot, 'Ash-Wednesday' (1930)

III

At the first turning of the second stair
I turned and saw below
The same shape twisted on the banister
Under the vapour in the fetid air
Struggling with the devil of the stairs
 who wears
The deceitful face of hope and of
 despair.

At the second turning of the second stair
I left them twisting, turning below;
There were no more faces and the stair
 was dark,
Damp, jaggèd, like an old man's mouth
 drivelling, beyond repair,
Or the toothed gullet of an agèd shark.

At the first turning of the third stair
Was a slotted window bellied like the
 fig's fruit
And beyond the hawthorn blossom and
 a pasture scene
The broadbacked figure drest in blue
 and green
Enchanted the maytime with an antique
 flute.
Blown hair is sweet, brown hair over the
 mouth blown,
Lilac and brown hair;
Distraction, music of the flute, stops and
 steps of the mind over the third stair,
Fading, fading; strength beyond hope
 and despair
Climbing the third stair.

Lord, I am not worthy
Lord, I am not worthy
 but speak the word only.

T. S. Eliot
Collected Poems 1909–1962, 1974

T. S. Eliot, *Four Quartets* (1935–42): 'East Coker' (1940)

IV

The wounded surgeon plies the steel
That questions the distempered part;
Beneath the bleeding hands we feel
The sharp compassion of the healer's art
Resolving the enigma of the fever chart.

Our only health is the disease
If we obey the dying nurse
Whose constant care is not to please
But to remind us of our, and Adam's
 curse,
And that, to be restored, our sickness
 must grow worse.

The whole earth is our hospital
Endowed by the ruined millionaire,
Wherein, if we do well, we shall
Die of the absolute paternal care
That will not leave us, but prevents us
 everywhere.

The chill ascends from feet to knees,
The fever sings in mental wires.
If to be warmed, then I must freeze
And quake in frigid purgatorial fires
Of which the flame is roses, and the
 smoke is briars.

The dripping blood our only drink,
The bloody flesh our only food:
In spite of which we like to think
That we are sound, substantial flesh and
 blood –
Again, in spite of that, we call this
 Friday good.

T. S. Eliot
Collected Poems 1909–1962, 1974

W. B. Yeats, 'The Second Coming' (1920)

Turning and turning in the widening
 gyre
The falcon cannot hear the falconer;
Things fall apart; the centre cannot
 hold;
Mere anarchy is loosed upon the world,
The blood-dimmed tide is loosed, and
 everywhere
The ceremony of innocence is drowned;
The best lack all conviction, while the
 worst
Are full of passionate intensity.

Surely some revelation is at hand;
Surely the Second Coming is at hand.
The Second Coming! Hardly are those
 words out
When a vast image out of *Spiritus
 Mundi*
Troubles my sight: somewhere in sands
 of the desert
A shape with lion body and the head of
 a man,
A gaze blank and pitiless as the sun,
Is moving its slow thighs, while all about
 it
Reel shadows of the indignant desert
 birds.
The darkness drops again; but now I
 know
That twenty centuries of stony sleep
Were vexed to nightmare by a rocking
 cradle,
And what rough beast, its hour come
 round at last,
Slouches towards Bethlehem to be born?

*The Poems of W. B. Yeats:
A New Edition*, edited by
Richard J. Finneran
1952

Looking at Bacon

Bacon (below) may have found difficulty in talking about painting, but his work has given rise to numerous commentaries and 'readings'. Some of the aspects that make Bacon's art so distinctive are highlighted here by Gilles Deleuze and by John Russell in his sensitive assessment of the painter.

Modern representation and photography

Francis Bacon: Logique de la sensation – *Deleuze's often-quoted book is as much a work of philosophy as of criticism.*

The painting must snatch the Figure from the grip of the figurative. But Bacon puts forward two reasons why the old style of painting does not have the same relationship with representation and illustration as modern painting. On the one hand the photograph has taken over the illustrative and documentary function, with the result that modern painting is no longer required to fulfil this function as painting used to do. On the other hand old-style painting was still conditioned by certain 'religious possibilities' that gave a pictorial sense to the representation, whereas modern painting is an atheistic game....

It is not true to say that religious feeling upheld representation in the old style of painting: on the contrary, it facilitated a liberation of the Figures, a shift away from representation of

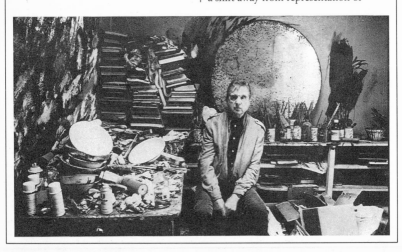

any kind. Nor is it true to say that abandoning representation is easier for modern painting since it operates as a kind of game. On the contrary, modern painting is invaded, beleaguered, by photographs, which fill the canvas before the artist has even set to work. Indeed, it would be a mistake to suppose that the artist works on a plain white surface. The entire surface is already potentially swamped with all manner of photographic images from which the artist must seek to free himself. This is what Bacon means when he says that the photograph is not a representation of what one sees, but that it is what modern people see. It is not dangerous merely because it is figurative, but because it claims a pre-eminent role in the field of visual perception, and therefore in painting. Having abandoned religious feeling, but finding itself under siege from photographic images, modern painting is thus far less well placed (whatever anyone may say to the contrary) to break with representation, which would seem to be the pitiful province carved out for it. It has required the extraordinary efforts of abstract painting – which provides ample evidence of the difficulty – to wrest modern art from the grip of representation....

Head, face, meat

But is it possible to say the same thing, exactly the same thing, about meat and the head – that it is the zone of objective indecision in people and animals? Can one say objectively that the head is meat (as much as meat is spirit)? Of all parts of the body, is the head not closest to the bones? Look at El Greco, or Soutine. But it seems that Bacon experiences the head differently. In his case bones belong to the face, not to the head.

There is no death's-head according to Bacon. The head is de-boned rather than bony. And yet it is not in the least soft, but solid and firm. The head is flesh, and the mask itself is not a funeral mask, but a block of firm flesh that is separate from the bones – as in the studies for a portrait of William Blake. Bacon's own head is a block of flesh haunted by an extraordinarily fine expression radiating from eyes without sockets, and he praises Rembrandt for having succeeded in painting one of his last self-portraits as just such a block of flesh without any sockets. The relationship head-meat undergoes a process of intensification in Bacon's work during which it becomes increasingly intimate. To begin with, the meat (flesh on one side, bone on the other) appears at the edge of the ring or railing where the Figure-head takes up its position; but it is also the dense rain of flesh surrounding the head whose face disintegrates beneath the umbrella. It is meat that provokes the scream emanating from the Pope's mouth, and the pity expressed in his eyes. Later the meat has a head and descends headfirst from the cross, as in the two earlier *Crucifixions*. Later still the various heads series affirm their identity with meat, and among the most beautiful are those that are painted in meat colours, red and blue. Finally the meat is itself head, and the head has become the non-localized power of the meat, as in *Fragment of a Crucifixion* of 1950, where the meat as a whole is shrieking under the gaze of a dog-spirit which is leaning over the top of the cross. What Bacon dislikes about this painting is the conspicuous simplicity of the procedure, which merely required that he scoop out a mouth in the midst of the meat. Again we should note the affinity of the mouth, and the interior

of the mouth, with meat, and ultimately see the open mouth strictly as a severed artery in cross-section, or even a jacket sleeve serving in place of an artery, as in the case of the bloody parcel in *Triptych Inspired by T.S. Eliot's Poem 'Sweeney Agonistes'*. The mouth then acquires the power of non-localization that turns the meat in its entirety into a faceless head. The head is no longer an individual organ, but the aperture through which the entire body escapes, and through which the flesh descends (it has to go through the process of free, involuntary marks)....

Scream and violence

The scream is a special case that needs considering. Why is it that Bacon regards the scream as one of the most important objects of painting?... When Bacon's figures scream they are always prey to invisible and intangible forces that blur the visible spectacle and flow beyond the boundaries even of pain and sensation. This is what Bacon means when he talks of wanting to 'paint the scream more than the horror'. One could set out the problem thus: either I paint the horror and omit to paint the scream, since I am representing the thing that is horrible; or I paint the scream, and I do not paint the visible horror, and continue to paint the visible horror less and less, since it is as if the scream had captured or detected an invisible force.... Bacon creates the painting of the scream because he puts the visible aspect of the scream, the mouth open wide like a shadowy gulf, in touch with invisible forces that are no more than the forces of the future. It was Kafka who spoke of detecting the diabolic powers of the future knocking at the door. Their potentiality lies in every scream. Innocent X screams,

but he screams behind the curtain, not merely as someone who can no longer be seen, but as someone who himself cannot see, who has nothing left to see, whose sole remaining function is to make visible those forces of the invisible that cause him to scream, those powers of the future. We express it in the phrase 'scream *at*' – not scream *before* or *of*, but scream *at* death, etc, to suggest this connecting of forces, the tangible force of the scream and the intangible force of the thing that provokes the scream.

Though curious, the point is a vital one. When Bacon distinguishes between two different types of violence, that of the visual spectacle and that of the sensation, and says that we have to relinquish one in order to attain the other, this constitutes a kind of declaration of faith in life. The interviews contain numerous declarations of this kind: according to Bacon he is cerebrally pessimistic – which is to say that he scarcely *sees* anything but horrifying elements to paint: the horrors of the world – but nervously optimistic because visible representation is secondary in painting and continues to assume less and less importance. Bacon was to reproach himself for painting the horror too much – as if the horror was sufficient to lift us out of the representational – and moves increasingly towards a Figure free from horror. But in what sense is electing to paint 'the scream more than the horror', the violence of the sensation rather than the violence of the spectacle, a vital act of faith? Are not the invisible forces, the powers of the future, already present, and far less easily surmounted than the worst spectacle and even the worst pain? Yes, in a sense, as all meat demonstrates. But in another sense, no. When the visible body, like a wrestler,

confronts the powers of the invisible it gives them no other visibility than its own. And it is in that very visibility that the body actively struggles, affirming a possibility of triumphing that was not accessible to it as long as those powers remained invisible in the midst of a spectacle sapping us of our strength and causing us to turn away from it. It is as if a fight were now possible. The struggle with darkness is the only real struggle. When the visual sensation confronts the invisible force that is the condition for its existence, it releases a new force that can overcome, or alternatively befriend, the invisible force. Life screams *at* death, but death is no longer that excessively visible thing that drains away our strength; it is that invisible force that life detects, flushes out and renders visible through the scream. It is from the point of view of life that death is judged, and not the reverse position, which we were content to adopt. Bacon no less than Beckett is one of those authors who can speak in the name of an intensely charged life, for an even more intensely charged life. He is not a painter who 'believes' in death. His representational concern with the sordid is in the service of a Figure increasingly powerfully bound up with life. Bacon, as much as Beckett or Kafka, deserves our respect for the indomitable Figures he has created, Figures indomitable through their insistence, through their presence, at the very instant of 'representing' loathsomeness, mutilation and prosthesis, collapse and failure. They have given life a new, and extremely direct, capacity for laughter....

Gilles Deleuze, *Francis Bacon: Logique de la sensation,* 1981

Distortion in portrait painting

It is worth saying again that Bacon does not regard any of his heads as nightmare images, or as portraits of degradation, or as any of the other things which legend attributes to them. There is nothing gratituitous or wilful about the distortions which he imposes upon the sitters' features (not least, his own). Anyone who knows even one of the sitters will end by agreeing with him that, although the features as we know them in everyday life may disappear from time to time in a chromatic swirl of paint or be blotted from view by an imperious wipe with a towel, individual aspects of the sitter are shown to us, by way of compensation, with an intensity not often encountered in life. The eye, above all, has a way of fixing us with an urgency which we cannot forget. The mouth is realized, from time to time, with a vitality that makes ordinary portraiture look vapid and deceitful. The way hair sits on a scalp, the double tunnel of the nostrils, the interlock of colour and substance in flesh which is thoroughly aroused – all these come out in the single heads, and come out in ways which make talk of 'distortion' and 'artifice' seem quite ridiculous.

These pictures stand up, therefore, as representations of known persons. They do not offer us a walk around these persons, according to cubist practice. Nor do they show them in serial guise, as would happen if successive frames from a movie were spread out, fan-wise, before us. They offer a superimposition of states, in which certain characteristics of the person concerned appear with exceptional intensity, while others are obliterated. Risk is built into the picture; without it, this way of painting would soften into a decorative convention.

John Russell
Francis Bacon, 1993

Head I (1948) is given a voice

Appropriating Bacon's image, the Peruvian writer Mario Vargas Llosa used it, with paintings by Titian, Boucher and Fra Angelico, as a springboard for a novel about sexual love. For once the painting (below) influenced the literary work, rather than the other way around, something of which Bacon would have approved.

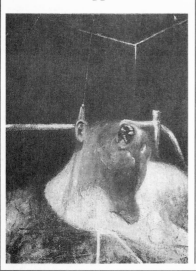

Profile of a human being

My left ear was bitten off in a fight with another human being, as I remember. But I hear the sounds of the world clearly through the thin slit that remains. I also see things, though only obliquely and with difficulty. Because, even though not apparent at first glance, this bluish protuberance, to the left of my mouth, is an eye…. It has no eyelid and frequently oozes tears, but it allows me to distract myself watching television and, above all, to detect in a flash the appearance of the enemy.

The glass cube I live in is my home. I can see through the walls of it, but no one can see me from the outside: a very handy system for ensuring the safety of the home, in this era of terrible traps. The glass panes of my dwelling are, of course, bulletproof, germproof, radiationproof and soundproof. They are continually perfumed with the distinctive odour of armpits and musk, which to me – and only to me, I know – is delightful.

I have a very highly developed sense of smell and it is by way of my nose that I experience the greatest pleasure and the greatest pain. Ought I to call this gigantic membranous organ that registers all scents, even the most subtle, a nose? I am referring to the greyish shape, covered with white crusts, that begins at my mouth and extends, increasing in size, down to my bull neck. No, it is not a goitre or an acromegalic Adam's apple. It is my nose. I know that it is neither beautiful nor useful, since its excessive sensibility makes it an indescribable torment when a rat is rotting in the vicinity or fetid materials pass through the drainpipes that run through my home. Nonetheless, I revere it and sometimes think that

my nose is the seat of my soul.

I have no arms or legs, but my four stumps are nicely healed over and well toughened, so that I can move about easily along the ground and can even run if need be. My enemies have never been able to catch me in any of their roundups thus far. How did I lose my hands and feet? An accident at work, perhaps; or maybe some medicine my mother took so as to have an easy pregnancy (science doesn't come up with the right answer in all cases, unfortunately).

My sex organ is intact. I can make love, on condition that the young fellow or the female acting as my *partenaire* allows me to position myself in such a way that my boils don't rub against his or her body, for if they burst they leak stinking pus and I suffer terrible pain. I like to fornicate, and I would say that, in a certain sense, I am a voluptuary. I often have fiascoes or experience a humiliating premature ejaculation, it is true. But, other times, I have prolonged and repeated orgasms that give me the sensation of being as ethereal and radiant as the Archangel Gabriel. The repulsion I inspire in my lovers turns into attraction, and even into delirium, once they overcome – thanks almost always to alcohol or drugs – their initial prejudices and agree to do amorous battle with me on a bed. Women even come to love me, in fact, and youngsters become addicted to my ugliness. In the depths of her soul, Beauty was always fascinated by the Beast, as so many fantastic tales and mythologies recount, and it is only in rare cases that the heart of a good-looking youth does not harbour something perverse. No one has ever regretted being my lover. Males and females alike thank me for having given them advanced instruction in the fine art of combining desire and the horrible so as to give pleasure. They learned from me that everything is and can be erogenous and that, associated with love, the basest organic functions, including those of the lower abdomen, become spiritualized and ennobled. The dance of gerunds they perform with me – belching, urinating, defecating – lingers with them afterward like a memory of times gone by, that descent into filth (something that tempts all of them yet few dare to undertake) made in my company.

My greatest source of pride is my mouth. It is not true that it is open wide because I am forever howling in despair. I keep it wide open like that to show off my sharp white teeth. Is there anyone who wouldn't envy them? I'm missing only two or three of them. The rest are still strong and carnivorous. If necessary, they crush stones. But they prefer to feed on the breasts and hindquarters of calves, to sink into the little tits and thighs of hens and capons or the throats of little birds. Eating flesh is a prerogative of the gods.

I am not a miserable wretch, nor do I want people to pity me. I am what I am and that's enough for me. Knowing that others are worse off is a great consolation, of course. It is possible that God exists, but at this point in history, with everything that has happened to us, does it matter? That the world might have been better than it is? Yes, perhaps, but what's the use of mulling over a question like that? I've survived and, despite appearances, I am part of the human race.

Take a good look at me, my love. Recognize me, and recognize yourself.

Mario Vargas Llosa
In Praise of the Stepmother,
translated by Helen Lane, 1991

CHRONOLOGY

1909
Born in Dublin on 28 October, the second of five children. Francis's father, Edward Bacon, and his mother Winifred (née Firth) are both of English nationality. The family home, Canny Court, is in County Kildare. The family lives in Ireland as Edward Bacon is a racehorse breeder and trainer.

1914
Following the declaration of war, Edward goes to work in the War Office and the family settles in Westbourne Terrace in London. Immediately after the conflict, the Bacons return to Ireland, living for a while at Abbeyleix, in a house called Farmleigh that had belonged to Francis' maternal grandmother. The family move frequently, living alternately in Ireland and in England. Francis Bacon suffers from asthma and rarely goes to school, being taught by private tutors and attending Dean Close School in Cheltenham for a year.

1925–6
Following a series of violent disagreements with his father, Bacon leaves for London. Survives by doing various jobs and on the modest sums his mother sends him.

1927–9
With an older friend, he travels to Berlin, a city at that time permeated by an atmosphere of great freedom and intense creativity. Two months later, he goes to Paris, spending more than a year there and earning his living by doing odd jobs and a few commissions for interior decoration. The Picasso exhibition held at the Galerie Paul Rosenberg determines his decision to become a painter. He begins to draw and paint. Spends three months living with a family near Chantilly and while there is fascinated by the manner in which Poussin succeeded in rendering the human cry in his painting *The Massacre of the Innocents*.

1929
On returning to London, he takes a studio in Queensberry Mews West, South Kensington, where he exhibits rugs, pieces of furniture and watercolours. Lives in relative poverty. Meets the Australian artist Roy de Maistre and, self-taught, begins to paint in oils.

1929–30
Together with de Maistre, mounts a small exhibition of oil paintings, watercolours and furniture in his studio. *The Studio* devotes a double-page article to his work, entitled 'The 1930 Look in British Decoration'.

1931
Moves to Fulham Road, gradually giving up interior decoration commissions to devote himself to painting. Works in various office jobs or as a telephonist, cook or waiter.

1933
Takes part in two collective shows at the Mayor Gallery. A reproduction of his *Crucifixion* (1933) is published in Herbert Read's celebrated work *Art Now*. One of the three *Crucifixions* painted in this same year is bought by the well-known collector Sir Michael Sadler. Moves once again, this time to a studio in Royal Hospital Road, Chelsea.

1934
First one-man show held in the basement of Sunderland House in Curzon Street, belonging to a friend and which he was to call the 'Transition Gallery'. Disheartened by his lack of success, he paints less and less, devoting his time to gambling.

1936
His work is rejected by the International Surrealist Exhibition, at the New Burlington Galleries in London, being considered insufficiently Surrealist. Rents a house in Glebe Place, Chelsea.

1937
Takes part in the group show 'Young English Painters', organized by his friend Eric Hall at Agnew's in London, exhibiting three paintings, including *Figures in a Garden*. Other artists participating in the show include Roy de Maistre, Ivon Hitchens, John Piper, Ceri Richards, Victor Pasmore and Graham Sutherland, all of whom were friends of Bacon.

1941–4
Lives for a while in the country at Petersfield, Hampshire. Returns to London and rents John Everett Millais's former studio in Cromwell Place, South Kensington. Declared unfit for service on account of his asthma, he is assigned to the Civil Defence Corps (ARP). Destroys most of his earlier work, with the exception of a dozen oil paintings.

1944
Starts to paint again, notably *Three Studies for Figures at the Base of a Crucifixion*, a work strongly

influenced by Picasso. This triptych is exhibited at the Lefevre Gallery in London in April 1945, being subsequently acquired by the Tate Gallery in London in 1953.

1945–6

Exhibits in collective shows in London, as well as at an international exhibition of modern art held at UNESCO in Paris. *Painting 1946*, is bought by Erica Brausen, who was subsequently to become his agent and dealer. This canvas was later acquired by Alfred Barr in 1948 for the Museum of Modern Art in New York.

1946–50

Frequent periods spent in Monte Carlo in the company of Graham Sutherland. One-man shows at the Hanover Gallery, London. Begins work on the series of *Heads*, of which *Head VI* is considered as the first of his series of *Popes*. Uses Eadweard Muybridge's photographic studies as a source of reference for his paintings of animals and human figures. In 1950, visits his mother who had settled in South Africa, spending several days in Cairo *en route*. Teaches for a period at the Royal College of Art, London.

1951–4

Moves studio several times and, in 1953, shares a flat with David Sylvester. Takes part in numerous collective shows. Paints his first portrait of an identifiable person, *Lucian Freud*, as well as his first *Popes*. In 1952, travels to South Africa again. Exhibits landscapes inspired by Africa and the South of France. In October–November 1953, has his first one-man show abroad, held at Durlacher Brothers in New York. Paints *Two Figures*, generally considered one of his most important works. In 1954, paints the series *Man in Blue*. With Lucian Freud and Ben Nicholson, represents Britain at the 27th Venice Biennale. He does not attend the Biennale, but visits Ostia and Rome. He does not go to see Velázquez's portrait of *Pope Innocent X*, a reproduction of which provided the inspiration for his *Popes*.

1955

First retrospective exhibition of his work held at the Institute of Contemporary Arts in London. Collective exhibition at the Hanover Gallery, where he shows portraits of William Blake. Takes part in numerous group shows in the United States. Paints the portraits of the collectors Robert and Lisa Sainsbury, who become his patrons.

1956

In the summer, makes his first trip to Tangier to visit his friend Peter Lacy. Rents the apartment where he was frequently to stay during the next few years. Paints his first *Self-Portrait*.

1957

First one-man show in Paris (Galerie Rive Droite). Exhibits *Van Gogh* series at the Hanover Gallery.

1958

First one-man show in Italy (a retrospective held successively in Turin, Milan and Rome). Leaves the Hanover Gallery, signing a contract with Marlborough Fine Art in London. Represents Britain at the Carnegie Institute in Pittsburgh.

1959

Exhibits at the 5th São Paulo Bienal. Takes part in collective shows in Paris, New York and Kassel, West Germany. Paints for a while at St Ives in Cornwall, where he executes from memory a portrait of Muriel Belcher, owner of the Colony Club, his favourite stopping-off place in Soho.

1960

First exhibition at Marlborough Fine Art in London. Numerous other shows throughout Europe and the United States.

1961

Settles in Reece Mews, South Kensington, above a garage. This was to be his last studio, which he would occupy until his death.

1962

Paints his first large triptych, *Three Studies for a Crucifixion*, acquired by the Solomon R. Guggenheim Museum in New York. Major retrospective of his work at the Tate Gallery in London subsequently shown with a few alterations in Mannheim, Turin, Zurich and Amsterdam. Death of Peter Lacy. Friendship with Alberto Giacometti.

1963–4

Retrospective at the Solomon R. Guggenheim Museum in New York, subsequently shown in Chicago and Houston. Friendship with George Dyer, of whom he was to paint numerous portraits. First portrait of Isabel Rawsthorne. The Musée National d'Art Moderne in Paris acquires *Three Figures in a Room*. The Moderna Museet in Stockholm buys *Double Portrait of Lucian Freud and Frank Auerbach*.

1965

Retrospective at the Kunstverein in Hamburg, subsequently shown in Stockholm and Dublin. Paints his great *Crucifixion*, a triptych acquired

by the Bayerische Staatsgemäldesammlungen, Munich.

1966–7
Exhibits at the Galerie Maeght in Paris and attends the opening. Winner of the Rubens Prize awarded by the city of Siegen and of the Carnegie Institute Award in Painting at the Pittsburgh World Fair, the only awards he was to accept in his lifetime.

1968
Brief stay in New York for the opening of a show of his recent paintings at the Marlborough–Gerson Gallery.

1971–2
Major retrospective at the Grand Palais in Paris, then at the Kunsthalle, Düsseldorf. Death of his companion and model George Dyer in Paris. Paints the large *Triptych 1971* in his memory.

1972–4
Badly affected by George Dyer's death, he executes a series of three large triptychs (also known as *Black Triptychs, 1972, 1973, 1974*), as well as numerous self-portraits. Meets John Edwards, who was to become his companion and model.

1975
Major exhibition entitled 'Francis Bacon: Recent Paintings 1968–74' organized by Henry Geldzahler at the Metropolitan Museum of Art. Visits New York for the opening. Portraits of Peter Beard.

1976
First portrait of Michel Leiris.

1977
Attends the opening of his very successful exhibition at the Galerie Claude Bernard in Paris. Brief stay in Rome, where he visits Balthus.

1978–9
Paints the second portrait of Michel Leiris, as well as *Sphinx – Portrait of Muriel Belcher*, who had died shortly before.

1980
The Tate Gallery in London acquires his *Triptych August 1972*.

1981
Paints the *Triptych Inspired by the Oresteia of Aeschylus*.

1983
First exhibition in Japan (Tokyo, Kyoto and Nagoya).

1984
Paints a large triptych, *Three Studies for a Portrait of John Edwards*.

1985–6
Major retrospective at the Tate Gallery in London, subsequently shown in Stuttgart and Berlin. Returns to Berlin for the first time since 1927 to visit the exhibition. Paints a large triptych, *Study for Self-Portrait – Triptych*.

1988
Paints *Second Version of Triptych 1944*, exhibited as *Homage to Pierre Boulez* in Paris in April 1989. Exhibition at the Central House of Artists, New Tretyakov Gallery, Moscow.

1989–90
Numerous exhibitions, including those at Hirshhorn Museum and Sculpture Garden, Smithsonian Institution, Washington, D. C., subsequently shown in Los Angeles and New York, and one at Marlborough Fine Art, London (1989).

1991
Paints *Study from the Human Body*.

1992
While visiting a friend in Madrid, he suffers a fatal heart attack on 28 April at the age of eighty-two.

ONE-MAN EXHIBITIONS

1934
'Transition Gallery', London.

1949
Hanover Gallery, London.

1950
Hanover Gallery, London.

1951–2
Hanover Gallery, London.

1952–3
Hanover Gallery, London. Durlacher Brothers, New York. Beaux Arts Gallery, London.

1954
British Pavilion, Venice Biennale. Hanover Gallery, London

1955
Institute of Contemporary Arts, London. Hanover Gallery, London (with Scott and Sutherland).

1957
Galerie Rive Droite, Paris. Hanover Gallery, London.

1958
Galleria Galatea, Turin (then at the Galleria dell'Ariete, Milan, and L'Obelisco, Rome). Arts Council touring exhibition with Matthew Smith and Victor Pasmore.

1959
Richard Feigen Gallery, Chicago. Hanover Gallery, London. V Bienal, São Paulo.

1960
Marlborough Fine Art, London. University of California at Los Angeles (with Hyman Bloom).

1961
Nottingham University, Nottingham.

1962–3
Retrospective at the Tate Gallery, London. Later shown at the Kunsthalle, Mannheim: the Galleria Civica d'Arte Moderna, Turin; the Kunsthaus, Zurich; and (in 1963) at the Stedelijk Museum, Amsterdam. Galleria d'Arte Galatea, Milan.

1963–4
Retrospective at the Solomon R. Guggenheim Museum, New York; then at the Art Institute of Chicago and the Contemporary Art Association in Houston. Galleria il Centro, Naples (with Graham Sutherland). Marlborough Fine Art, London. Granville Gallery, New York.

1965
Retrospective at the Kunstverein, Hamburg; afterwards at the Moderna Museet, Stockholm, and the Municipal Gallery of Modern Art, Dublin. Marlborough Fine Art, London.

1966
Galleria Toninelli, Milan. Galerie Maeght, Paris.

1967
Galleria d'Arte Marlborough, Rome. Galleria Toninelli, Milan. Marlborough Fine Art, London. Oberes Schloss, Siegen (Rubens Prize Exhibition).

1968
Marlborough–Gerson Gallery, New York.

1970
Galleria d'Arte Galatea, Turin.

1971–2
Retrospective at the Grand Palais, Paris, and afterwards at the Kunsthalle, Düsseldorf.

1975
Metropolitan Museum of Art, New York. Galerie Marlborough, Zurich.

1976
Musée Cantini, Marseilles.

1977–8
Galerie Claude Bernard, Paris. Museo de Arte Moderno, Mexico, and then at the Museo de Arte Contemporáneo, Caracas.

1978
Fundácion Juan March, Madrid, and then at the Fundació Joan Miró, Barcelona.

1980
Marlborough Gallery, New York.

1983
National Museum of Modern Art, Tokyo; National Museum, Kyoto; Aichi Prefectural Art Gallery, Nagoya.

1984
Galerie Maeght Lelong, Paris. Marlborough Gallery, New York. Thomas Gibson Fine Art, London.

1985–6
Retrospective at the Tate Gallery, London, the Staatsgalerie, Stuttgart, and the Nationalgalerie, Berlin. Marlborough Fine Art, London.

1987
Marlborough Gallery, New York. Galerie Beyeler, Basel. Galerie Lelong, Paris.

1988–9
Central House of Artists, New Tretyakov Gallery, Moscow. Marlborough Fine Art, Tokyo. Marlborough Fine Art, London.

1989–90
Hirshhorn Museum and Sculpture Garden, Smithsonian Institution, Washington, D.C. Los Angeles County Museum of Art, and the Museum of Modern Art, New York. Marlborough Fine Art, London. Marlborough Gallery, New York.

1990–1
Tate Gallery, Liverpool.

1992–3
Galeria Marlborough, Madrid, and then at the Marlborough Gallery, New York. Museo d'Arte Moderna, Lugano. Museo Correr, Venice.

1996–7
Centre Georges Pompidou, Paris, and then at the Haus der Kunst, Munich.

FURTHER READING

EXHIBITION CATALOGUES

Francis Bacon, catalogue of the exhibition at the Grand Palais, Paris, 1971, and the Kunsthalle, Düsseldorf, 1972
Francis Bacon, catalogue of the exhibition at the Museo d'Arte Moderna, Lugano, 1993
Francis Bacon, catalogue of the exhibition at the Centre Georges Pompidou, Paris, 1996, and the Haus der Kunst, Munich, 1996–7
Bacon-Freud, catalogue of the exhibition at the Fondation Maeght, 1995
Corps crucifiés, catalogue of the exhibition at the Musée Picasso, Paris, 1992

INTERVIEWS

Francis Bacon in Conversation with Michel Archimbaud, 1993
Sylvester, David, *Interviews with Francis Bacon*, 1993

MONOGRAPHS AND BIOGRAPHIES

Ades, Dawn, and Andrew Forge, *Francis Bacon*, 1985

Alley, Ronald, and John Rothenstein, *Francis Bacon*, 1964
Anzieu, Didier, and Michèle Monjauze, *Francis Bacon*, 1993
Borel, France, *Bacon: Portraits and Self-Portraits*, 1996
Davies, Hugh, and Sally Yard, *Francis Bacon*, 1986
Deleuze, Gilles, *Francis Bacon: Logique de la sensation*, 1981
Farson, Daniel, *The Gilded Gutter Life of Francis Bacon*, 1993
Gowing, Lawrence, and Sam Hunter, *Francis Bacon*, 1989
Leiris, Michel, *Francis Bacon: Full Face and in Profile*, translated by John Weightman, 1983
Peppiatt, Michael, *Francis Bacon: Anatomy of an Enigma*, 1996
Russell, John, *Francis Bacon*, 1993
Sinclair, Andrew, *Francis Bacon: His Life and Violent Times*, 1993
Trucchi, Lorenza, *Francis Bacon*, translated by John Shepley, 1976

REVIEWS

Art International, no. 8, autumn 1989
Artstudio, no. 17, summer 1990
Opus International, no. 68, 1978

LIST OF ILLUSTRATIONS

CHAPTER 3

CHAPTER 4

DOCUMENTS

INDEX OF FRANCIS BACON'S WORKS

GENERAL INDEX

ACKNOWLEDGMENTS

The publishers particularly wish to thank Valerie Beston and her assistant Kate Austin at Marlborough Fine Art, London, in addition to the following publisher: La Différence. The author thanks Denis Jourdin, Michel Salsmann, Bruno Perramant, and in particular Lisa Wyant, for their kind help with bibliographic material; Fabrice Hergott, Hervé Vanel, Valérie Breuvart, Anna Hiddleston, Nathalie Garnier, Patrice Henry and the team responsible for the retrospective at the Centre Georges Pompidou, Paris; Michael Peppiatt; and Véronique P. for her patience and her support.

PHOTO CREDITS

TEXT CREDITS

Christophe Domino
is a writer and art critic.
In addition to monographs and texts for
exhibition catalogues he has written two books
on the collections held by the Musée National
d'Art Moderne (Centre Georges Pompidou), Paris,
which were published in 1992 and 1994.
He regularly gives talks at artistic and cultural
venues, such as schools of fine art, universities,
museums and art galleries.

Translated from the French by Ruth Sharman

For Harry N. Abrams, Inc.
Editor: Eve Sinaiko
Cover designer: Dana Sloan

Library of Congress Cataloging-in-Publication Data

Domino, Christophe.
[Francis Bacon. English]
Francis Bacon: painter of a dark vision/Christophe Domino.
p. cm. — (Discoveries)
Translated from French
Includes bibliographical references and index.
ISBN 0–8109–2811–6 (pbk.)
1. Bacon, Francis, 1909–92. 2. Painters—England—Biography.
I. Title. II. Series: Discoveries (New York, N. Y.)
ND497.B16D6613 1997
759.2—dc21 96–46897

Published in 1997 by Harry N. Abrams, Inc., New York
A Times Mirror Company

Printed and bound in Italy by Editoriale Libraria, Trieste